Wynford
Dewhurst

Manchester's Monet

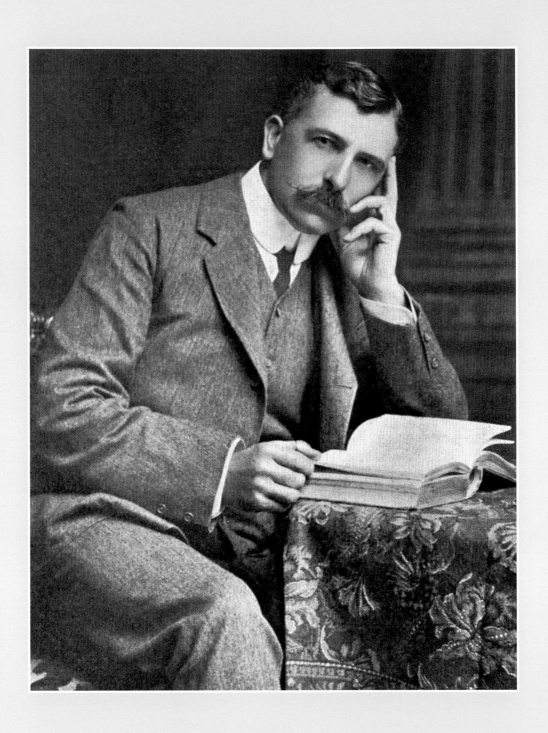

Wynford Dewhurst

Manchester's Monet

Roger Brown

Sansom &
Company

Published in conjunction with the
exhibition 'Wynford Dewhurst:
Manchester's Monet' held at
Manchester Art Gallery,
8 December 2016 – 23 April 2017

First published in 2016 by
Sansom and Company,
a publishing imprint of
Redcliffe Press Ltd.
81g Pembroke Road
Bristol BS8 3EA

www.sansomandcompany.co.uk
info@sansomandcompany.co.uk

Supported by:

**Manchester
Art Gallery**

Art Fund_

MARC FITCH FUND

ISBN 978-1-911408-00-0

British Library
Cataloguing-in-Publication Data

A catalogue record for this book is
available from the British Library

Design by Christopher Binding
www.binding-associates.com

Set in Humanist and Soho

Printed and bound by
Cambrian Printers Ltd

Opposite: *Normandy Poplars,
Seine Valley*, 1898 (detail)
ink on white paper, 20.4 x 26.6cm
Private Collection. Reproduced
from *The Artist*, March 1900

Previous page:
Wynford Dewhurst c 1910

Contents

**Nut Tree Farm,
Nether Alderley**

1890, watercolour

16 x 25cm

Private Collection

[inscribed verso: 'Where I spent my weekends for several years whilst living at Heaton Moor. This farm and many others adjoining belonged to Lord Stanley of Alderley.]

A Farm in Heaton Moor

c 1890, watercolour

16 x 25cm

Private Collection

Introduction

Mr Wynford Dewhurst is a landscape painter who means to build up and consolidate a style of his own in rendering Nature under her varying attitudes ... Although the finish in Mr Dewhurst's work is not carried as far as is usually done by landscape painters, there is no mistaking what the artist means ... Mr Dewhurst has a future before him which should bring him repute and position in the landscape-painting world.

Manchester Courier, 31 October 1899

M y interest in the painter and writer on art Wynford Dewhurst (1864-1941) stems from a chance remark made nearly ten years ago by an artist friend who was an admirer of Dewhurst's work and who asked me what I thought of it. I had to confess a total lack of knowledge of this English Impressionist painter who, I discovered later, wrote the first history of Impressionism in the English language and was a disciple of the acknowledged leader of the Impressionist group in France, so much so, that in a review of his work in 1910, the *Daily News* referred to him as 'England's Claude Monet'.[1] Dewhurst also had political ambitions, campaigning vigorously for a Ministry of Fine Arts at Westminster along the lines that he judged to be so successful in France. Like so many late Victorian artists, who were prolific and highly regarded in their day, Dewhurst's stock has declined and his reputation faded. Until now no monograph has been written on this complex and interesting man who, I believe, deserves to be re-evaluated and reconsidered as a significant figure in British art at the turn of the twentieth century.

Wynford Dewhurst was born in Manchester in 1864. Although embarking initially on a legal training he showed considerable artistic flair, having some of his drawings published in various local and national journals. In 1891, at the relatively advanced age of 27, he went to Paris to gain a training in the École des Beaux-Arts, where he was a pupil of the great classicist painter Jean-Léon Gérôme. In Paris he was immediately attracted to Impressionism.

He wrote in his book 'my conversion into an enthusiastic Impressionist was short, in fact an instantaneous process'. It was in 1904 that he published this book, *Impressionist Painting, Its Genesis and Development*, which he dedicated to Claude Monet. It was the first important study of the French Impressionists to be published in English. However, the book later became notorious because of his insistence that

Nut Tree Farm, Welsh Row, Nether Alderley 1896

Photo © The Francis Frith Collection

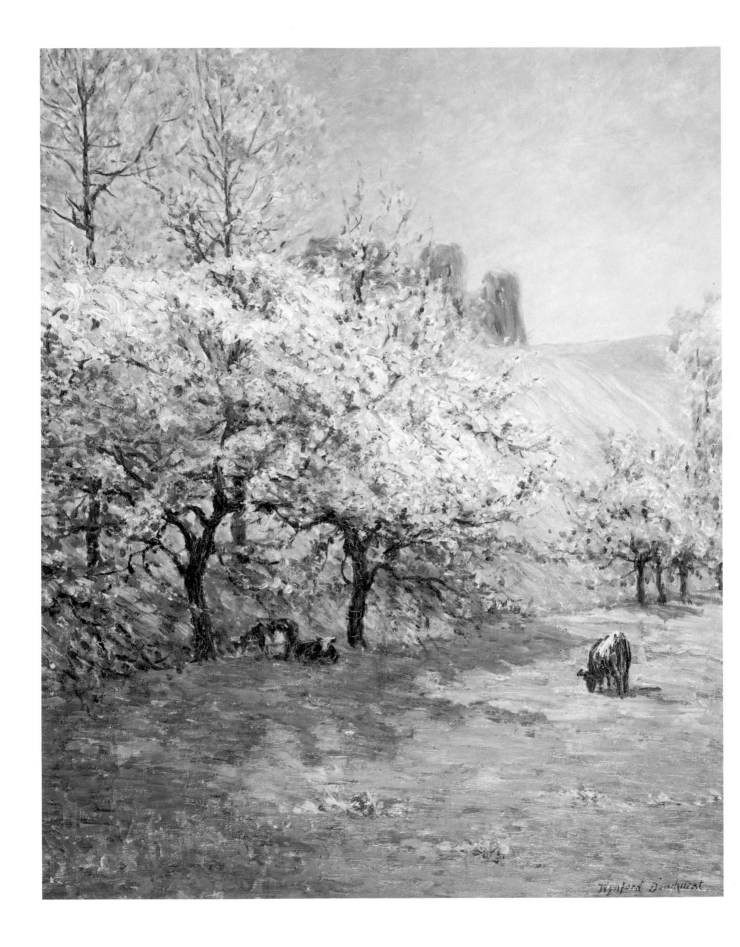

the English landscape tradition, especially the work of Constable and Turner, was at the root of modern French painting; although this was a contention shared by many of his contemporaries on both sides of the English Channel. Dewhurst's thesis was that 'the French artists simply developed a style which was British in its conception'. In so saying, he was trying to fend off the xenophobia and ridicule which greeted the arrival of works by the French Impressionists in London. By claiming a British antecedence for these works he was also attempting to justify the position of artists who, like himself, had taken up the Impressionist manner.

A committed Francophile, Wynford Dewhurst spent a large part of his working life in France and 80 per cent of his output was produced there. He was very proud of the two awards bestowed on him by the French government, under the *Ordre*

Antonia von Bulow
1894, a year before her marriage to Wynford Dewhurst

Impressionist Painting
published 1904

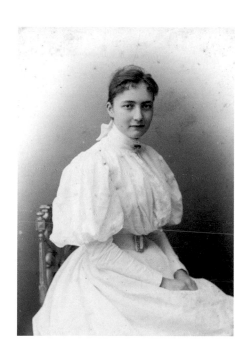

Château d'Arques-la-Bataille; Blossoms and Ruins
c 1897, oil on canvas
71 x 59cm

Private collection

des Palmes Académiques, which were awarded to foreigners for distinguished contributions to education and culture. After completing his training at the schools in Paris in 1895 he married Antonia von Bulow, an art student twelve years his junior. Initially they lived in an apartment in Paris and then moved to Arques-la-Bataille, close to Dieppe, where he found suitable motifs in the orchards and pastures of the Normandy countryside and the nearby Seine Valley. The first three of their six children were born in France, but by 1900 the family was back in England living in a large house in the countryside in Buckinghamshire.

The Town Hall and Post Office, Crozant
c1910, postcard

In spite of setting up home in England, Dewhurst returned to France very regularly to paint in the valleys of the Seine and the Creuse in the style of Monet, who became his principal mentor. In 1889 Claude Monet had spent a season in the Creuse Valley, a wild and isolated part of central France, where he painted a series of 24 pictures. Dewhurst rented a cottage there for the ten years up to the outbreak of the war in 1914 and would spend several months of each year, with his family, in the village of Crozant, painting the changing atmospheric conditions, both diurnal and seasonal. Primarily a landscape painter, he exhibited widely at home and abroad from 1897 when his first works were accepted by the Paris Salon.

In London he exhibited initially with the RBA and the New English Art Club, but also from 1914 to 1926 with the Royal Academy. He had a number of one-man shows, including at the Durand-Ruel Gallery in Paris and the Fine Art Society in London. The populist appeal of his pictures can be judged by the fact in 1908 he won a gold medal for the best landscape in oil at the very first *Daily Mail* Ideal Home Exhibition in London.

In addition, he was a prolific writer of articles and reviews for journals such as *The Studio, The Artist, Pall Mall Magazine* and *The Contemporary Review*. He was also in demand as a popular public speaker. In 1907 he was elected as a member of Buckinghamshire County Council and in 1913 he wrote a series of articles in *The Art Chronicle* advocating the establishment of a Ministry of Fine Arts. This was a cause very close to his heart and for many years he took every opportunity to point out how, in France, the arts benefited greatly from the support and financial assistance provided by central government.

Dewhurst was born in the Victorian era and remained a Victorian in outlook all his life, which makes his wholehearted adoption and endorsement of the Impressionist aesthetic somewhat surprising. There is a sense that in some respects

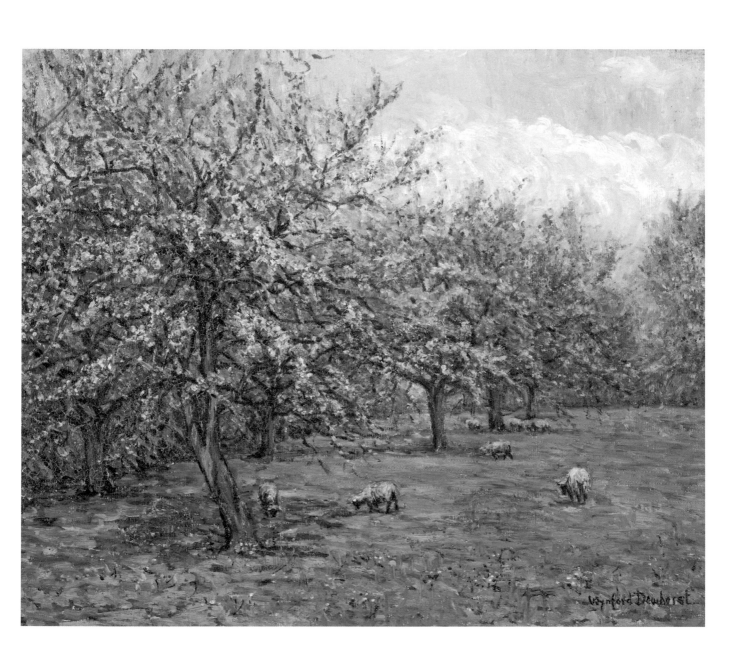

**Blossoms in England; Sheep
in an Orchard**
c 1902, oil on canvas, 58 x 72cm

Private collection

An Ancient Stronghold in France
c 1910, oil on canvas, 81 x 101cm

Bradford Art Galleries and Museums

his proselytising and enthusiasm for Impressionism was slightly 'behind the curve'. By the time he published *Impressionist Painting, Its Genesis and Development*, the movement had certainly become somewhat *passé* in Europe, where various manifestations of Post-Impressionism were underway. For example, the first 'Fauves' exhibition of Matisse and Derain was held in 1905 and Picasso's *Les Demoiselles d'Avignon* was painted in 1907. Even in Britain, where Impressionism was still not completely accepted, it had lost its revolutionary edge and in 1904 George Clausen, a convert to the cause, was appointed Professor of Painting at the Royal Academy. The following year, when the Paris dealer Paul Durand-Ruel staged a large exhibition of 315 Impressionist paintings at the Grafton Galleries in London, an art fund was set up by a number of influential art critics, academics and artists to secure one of these 'modern masters' for the nation.

Even so, English collectors, with a few notable exceptions, were still reluctant to commit to the 'new wave' coming from France, perhaps partly *because* it was coming from France! They were certainly not encouraged by some critics, such as the anonymous reviewer in *The Times* in June 1900 who wrote, 'We ourselves are inclined to think that the craze for impressionist landscapists will not last'.[2] This disdain from certain art critics and the restraint among English collectors clearly irritated Dewhurst. In the preface to his book he explained his mission: 'It has always seemed to me astonishing that an art which has shown such magnificent proofs of virility, which has long been accepted at its true value on the Continent and in America, should be comparatively neglected in my own country.' He went on to state that 'a stimulating propaganda' was needed to win over the English public and he intended that his book would provide it.

It was not until the 1990s that renewed interest in British Impressionism was stimulated, largely by the work of Professor Kenneth McConkey. His book *British Impressionism* (1989) was seminal in presenting a reappraisal of the phenomenon, chronicling the tensions that existed at the turn of the twentieth century between the English and French art communities, and how eventually a distinctly British form of Impressionism emerged. This prompts the question, which we will address later, as to whether Dewhurst was ever a 'British' Impressionist, or did he remain a 'French' Impressionist by temperament and practice?

Then, in 1995, a major exhibition of British Impressionism was held at the Barbican Centre in London and the catalogue gave prominence to Dewhurst as one of the leading apologists for Impressionism and a 'dedicated follower of Monet'. The exhibition included four pictures by Dewhurst, *The Picnic* (Manchester Art Gallery), *French Landscape* and *Summer Mist, Valley of La Creuse* (National Museum of Wales, Cardiff) and *An Ancient Stronghold in France* (Bradford Art Galleries and Museums).

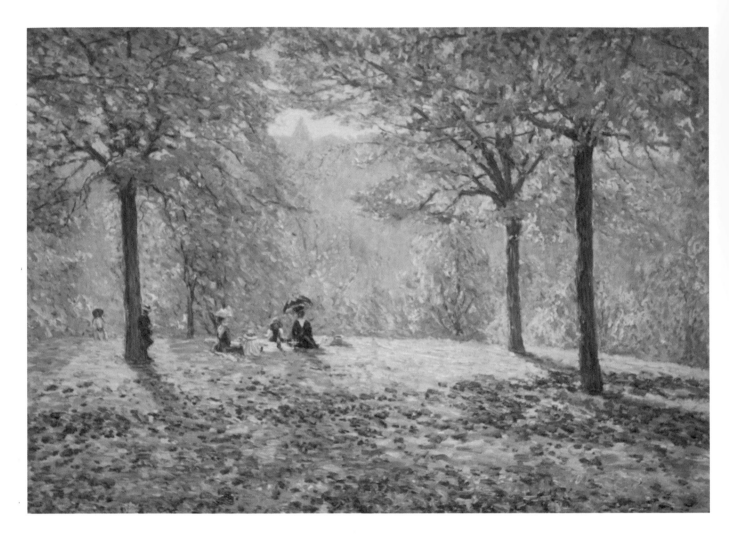

In the catalogue Kenneth McConkey comments: 'In later years Dewhurst's handling became more expressive, especially in a series of works produced in the valley of La Creuse. Here the bright, almost garish, colours again echo Monet, although in some instances they achieve an unintended Fauvist intensity.'[3]

It remains to be decided whether Wynford Dewhurst should be best remembered for his paintings or his writings. One twentieth-century commentator said of his book 'that it did more to make the [Impressionist] movement popular in England than any other publication, and this, in part at least, because he paid such emphasis - to the point of exaggeration - on the movement's English ancestry'.[4] So perhaps it can be argued that Dewhurst's mission was accomplished primarily by the pen, rather than with the brush.

Financial disaster in mid-life appears to have extinguished his creative drive. After a one-man show of his pastels at the Fine Art Society in 1926 he seems to have produced very little work and he died in relative obscurity in 1941. It is hoped that this book will illustrate both his key role in Anglo-French artistic relations at the start of the twentieth century and the part he played, to use his own words, 'by precept and by example, to preach the doctrine of Impressionism, particularly in England, where it is so little known and appreciated'.[5]

Notes

1 *Daily News*, October 1900, quoted in the *Kent & Sussex Courier*, 21 October 1900, p. 3.

2 *The Times*, 5 June 1900, p. 11. A notice of the art shown at the Grand Palais during the Paris Exhibition of 1900. The anonymous correspondent sees Impressionism as a 'craze' that has been manipulated by the art dealers.

3 Kenneth McConkey, *Impressionism in Britain*, London, 1995, p. 120.

4 Bernard Denvir (ed.), *The Impressionists at First Hand*, London, 1987, p. 193.

5 Wynford Dewhurst, *Impressionist Painting, Its Genesis and Development*, London, 1904, p. vii.

I. Promoting Impressionism

'A stimulating propaganda being needed'

I trust that this volume may be of real service in the cause of art education, and that it may introduce to an extended circle of art-lovers the masterpieces of the great artists who founded and are continuing Impressionist Painting.

Wynford Dewhurst (1904)

Many people turned last night from the exhibition of the work of Impressionist painters in the Manchester City Art Gallery to listen to a lecture on the school by Mr Wynford Dewhurst... Discussing the historical development of the school, he spoke of Turner and Constable as its true inspirers. 'France through Turner's eyes, awakened to the beauty of light in nature, and through France the world at large has been enlightened'.

Manchester Guardian, 12 December 1907

Wynford Dewhurst's career as a writer began almost as suddenly as his conversion to Impressionism. In 1900 he burst into print in the artistic press with three articles on French painting. Perhaps he had decided it was not enough to lead the way merely by the example of his art. He tells us later, in his book, that he had concluded that, 'a stimulating propaganda' was needed, by way of lectures and the written word, to promote his belief in the Impressionist credo and methodology. To effect this he admitted that he had 'invaded ... the domain of the writer on art, a sphere of activity for which I feel myself none too well equipped'. But he showed no bashfulness in putting his ideas forward. As with everything he did, when he took up the pen in 1900 there was no tentativeness in his approach, and he immediately began expressing his views with assurance and absolute conviction.

Although Dewhurst claims that when he arrived in Paris his conversion to Impressionism was immediate, it is clear he had had exposure to the new school of painting before his entry into 'The City of Light'. In 1890 he had visited an exhibition in Bradford of the collection of John Maddocks, a mill-owner and former mayor of Bradford, who was one of the first Englishmen to acquire works by the Impressionists. Dewhurst recalls seeing in the exhibition a landscape by the Belgian Impressionist, or 'luminist' as he preferred to be called, Emile Claus, and remembers vividly the pleasure it gave him. He goes on to say, 'It was a revelation to those artists who found themselves in Bradford at that period ... which aroused in several breasts a feeling of emulation.' So it is possible that it was in Bradford, rather than Paris, that Dewhurst

Harvest: Sunlight Effect (detail)
c 1913, oil on canvas
79 x 99cm
Private collection
[Exhibited RA 1914. No.257]

Emile Claus (1849-1924)
End of August 1909
1909, oil on canvas
90 x 130cm (detail)

Private collection/Photo © Christie's
Images/Bridgeman Images

Wynford Dewhurst
as a student in Paris, c 1893.
Photograph of a painting
by an unknown artist

experienced his Pauline conversion, for in the following year, 1891, he gave up his intended career in law and set out for Paris, at the age of 27, to study at the École des Beaux-Arts. Dewhurst also reveals in the preface to his book that, 'For years, as a hobby, I had collected all manner of documents bearing upon the subject of Impressionism, and the mass of material which thus accumulated formed the basis for several articles which have appeared under my name in the English magazines.'

The first recorded article by Dewhurst, 'Picturesque France' in *The Artist* of March 1900, was a simple travelogue in which he takes a boat trip down the river Seine from Paris to Rouen, extolling its beauty and suitability for an artist looking for inspiring motifs. In fact, he says the river provides, 'many a season's interesting work'. The article is illustrated entirely with his own drawings and from a date on one of them we can tell the journey was made in 1898. It is the only article he wrote which was not overtly trumpeting the glories of Impressionism. But he does vicariously manage to get this message across through a reference to his hero Claude Monet, who in 1883 had taken up residence at Giverny, within sight of the Seine. Dewhurst says that 'the chief attraction to the modern landscapist is the 'atmosphere' of this part of France, which is special and probably unique. He suggests it was not by chance that the veteran *paysagiste*, Monet, settled here. He goes on to claim that the 'fresh, intense, liquid, summer blue skies' are the everlasting joy of the 'sunlight painters' who congregate here, and he concludes his eulogy on the attractions of the Seine Valley to the painter by saying, 'Such exquisite gradations of tints, such opalescent grey days and misty, toneful effects of morn and eve, render the lot of these painters an enviable one.'[1]

Dewhurst certainly wrote from practical experience. In his first few years after leaving the Paris schools he painted almost exclusively in the Seine Valley and in the hinterland of Dieppe. It is clear that during these years he was inspired by the proximity of his self-appointed mentor Monet and he often painted and sketched in and around Giverny. He set himself the task of replicating the painting technique of his hero and surprisingly quickly was producing work in the manner of Monet. Art historian Kenneth McConkey has written, 'Not only did he position himself before Monet's motifs, he imitated Monet's style and at times, in such works as *The Picnic*, in the juxtaposition of dabs of bright pigment, achieved the palpable density of Monet's ether.'[2]

In relatively early works, such as *French Landscape* and *The Old Road, Giverny*, Dewhurst shows that he has assimilated and mastered Impressionist techniques. In these, and later works painted in the valley of La Creuse, he achieves a surface texture in his paintings similar to Monet's. Occasionally, McConkey says, he lifted himself 'beyond the ranks of imitator', although overall, 'he lacked Monet's ability to achieve compositional strength'.[3]

**Typical Scenery in
the Seine Valley**
1898, ink on white paper
29.7 x 15cm

Private collection. Reproduced
from *The Artist*, March 1900

**The 'Restaurant du
Monde', Poissy**
1898, ink on white paper
13 x 21cm

Private collection. Reproduced
from *The Artist*, March 1900

Giverny sur Seine
1898, ink on white paper
14.5 x 26cm

Private collection. Reproduced
from *The Artist*, March 1900

**Normandy Poplars,
Seine Valley**
1898, ink on white paper
20.4 x 26.6cm

Private collection. Reproduced
from *The Artist*, March 1900

The Old Road, Giverny
1896, oil on canvas
59 x 80.5cm

Private collection
[Exhibited at the Paris Salon, 1897]

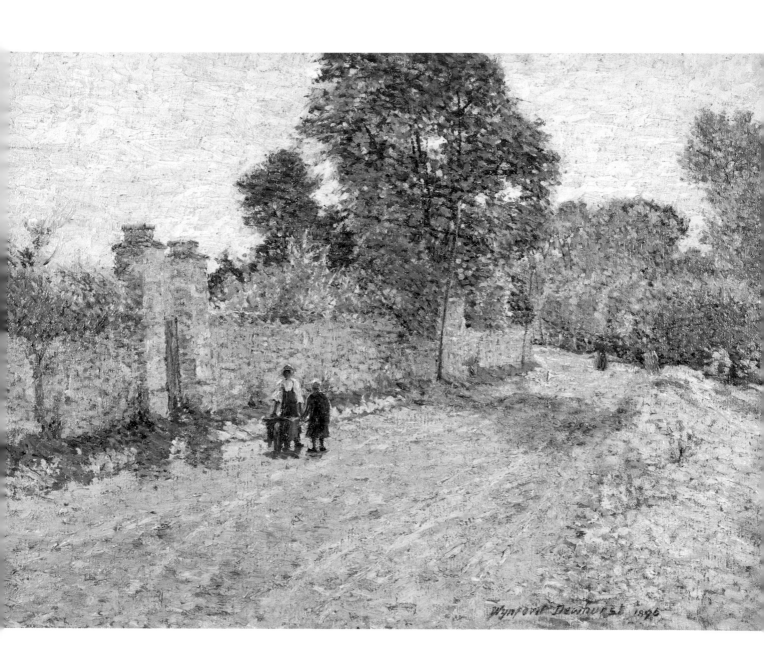

Dewhurst was sensitive to the atmospheric conditions which had so attracted Monet to the valley of the Seine. As we have already noted, in his first published article in *The Artist* of March 1900, he remarks on this unique atmosphere and he writes much later about how he experienced the violet light which can be discerned in some of Monet's noonday canvases:

I remember distinctly, during the summer of 1901, at Les Andelys-on-Seine, that upon two days and for two hours in the afternoons of those days all Nature, animate and inanimate, bore the aspect of things seen under a strong glare of violet light, exactly as though a tinted glass were suspended between the sun's rays and earth. The effect was most curious and disturbing. Nature appeared to be toneless and flat. Highlights and shadows are attenuated almost to extinction, whilst in this dull purple glare the heat became more intense than ever, possibly through lack of wind, for all was still.[4]

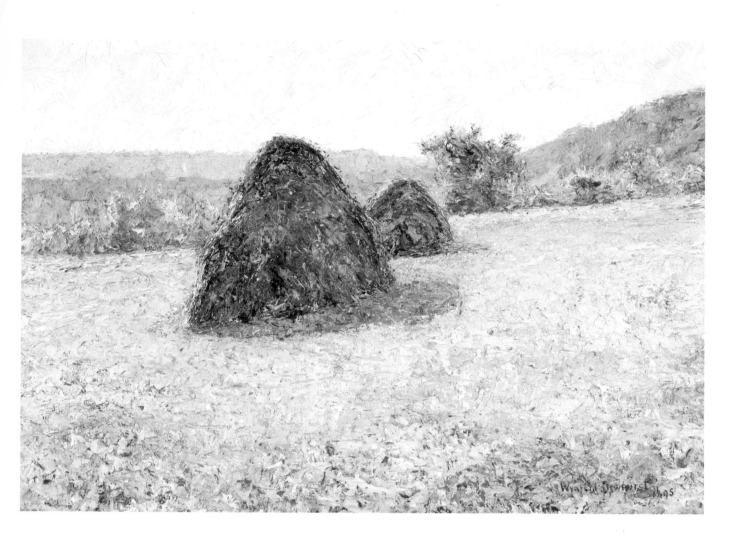

Haystacks
1895, oil on canvas
49.5 x 73cm

Private collection

Claude Monet (1840-1926)
Haystacks at Giverny
1884, oil on canvas
65 x 80cm

Private collection/Peter Willi/Bridgeman Images
[Exhibited at the Paris Salon, 1897]

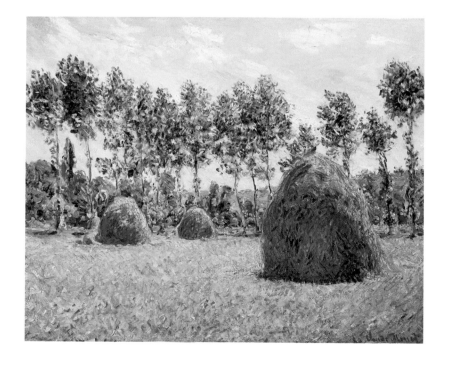

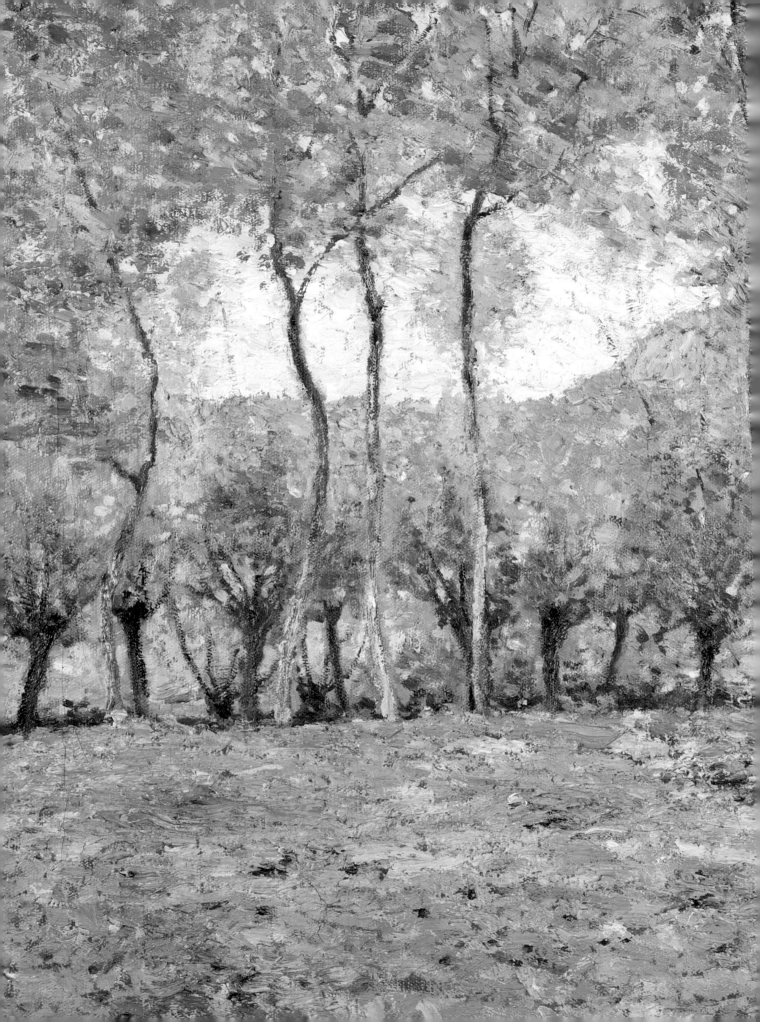

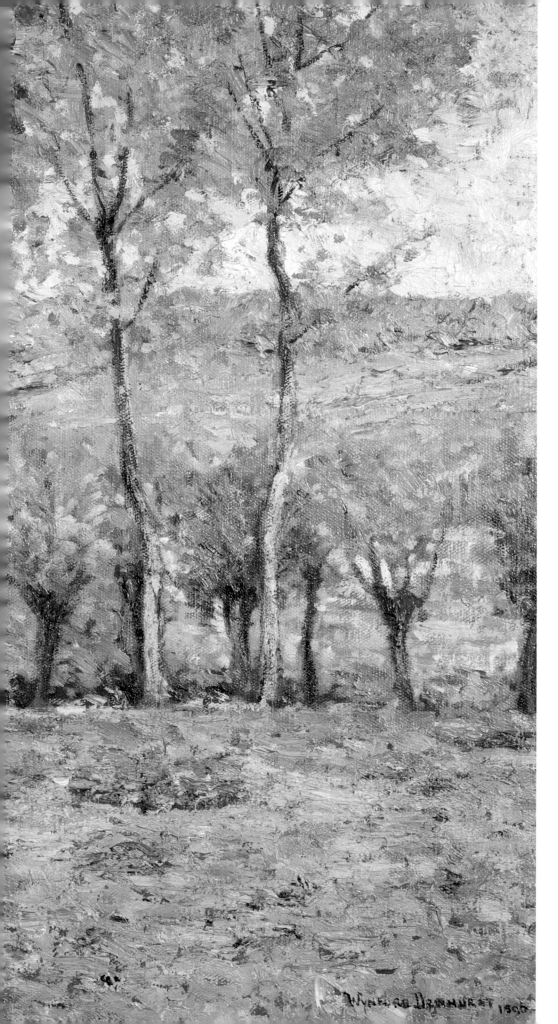

**Normandy Poplars and
Pollarded Willows,
Seine Valley**
1896, oil on canvas
59 x 79.5cm
Private collection

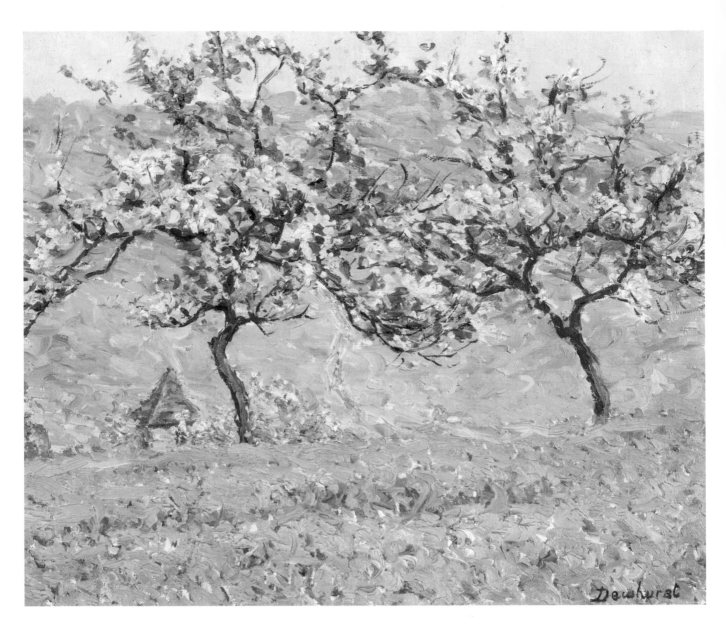

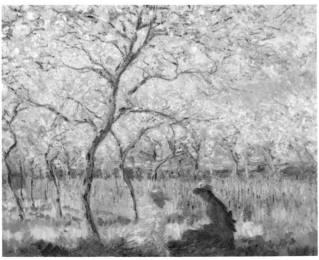

Blossoms with Church in Valley
c 1914, oil on panel
43 x 52cm
Private collection

Claude Monet (1840-1926)
Springtime
1886, oil on canvas
64.8 x 80.6cm

Fitzwilliam Museum, University of Cambridge/
Bridgeman Images

Springtime
c 1920-25, pastel
23.5 x 32.5cm
Private collection

It is not surprising therefore that the two further articles written by Dewhurst in 1900 were about his hero. 'Claude Monet – Impressionist' in the *Pall Mall Magazine* of June and 'A Great French Landscapist – Claude Monet' in *The Artist* in October. Both praised Monet as the leader and founder of the Impressionist movement in France and conjectured that he would be seen eventually as one of the world's greatest artists. He uses his account of Monet's career of struggle and endeavour to justify and normalise Impressionism. He begins his first article by positing, 'The time is now happily long past for the necessity of detailed exposition of, or apology for, "Impressionism" in Art.' Having thus disarmed his readers so deftly he goes on to say:

> It has been reserved for the present generation to witness a quite phenomenal artistic revolution ... a long acrimonious, and desolating struggle, between a small band of devoted painters, and the world of prejudice and distain.

> These men claimed, and won, firstly the right to exist by their labours, secondly freedom to exercise and propagate ideas such have since so radically changed and enlarged the practice

House by the Sea
1894, oil on board
59 x 44.5cm
[in the autumn of 1894 Dewhurst
toured the South of France]
Private collection

of landscape art. In this they were aided by a mere handful of far-sighted critics and patrons, who ... have for the past thirty years resolutely stemmed the tide of public obloquy, and without whose material assistance the pioneers of the Impressionist movement must inevitably have succumbed.[5]

Dewhurst continues, 'A truce is now declared ... and appreciation is the order of the day.' But he must surely have been conscious that, as with almost all his writing, he was overstating his case. By 1900 Impressionism had certainly been accepted by a small number of art critics and collectors in Britain, who were persuaded it was a legitimate art movement with an honourable provenance. But public opinion still needed convincing that it was not a huge confidence trick. In spite of Dewhurst's bold assurances, there were those who needed convincing that they were viewing great art with a permanence and a future. Even while Dewhurst was penning his articles, a review appeared in *The Times* in the summer of 1900 which we may take to sum up the feelings of the doubters:

> It is not easy to decide how far the admiration for these things, which is now very generally expressed in France and among collectors elsewhere, is genuine, and how far it is the result of a desire to appear 'in the movement,' carefully forced by one or two clever dealers. We ourselves are inclined to think that the craze for the impressionist landscapists will not last...[6]

In these early writings Dewhurst does not promote with any vigour what was later to become his *leitmotiv*, that Impressionism was of English origin and stems from the impact the work of Turner, Constable and Bonington made on the French art establishment of the 1820s and 1830s. He does mention *en passant* that in 1870, while in exile in London during the Franco-Prussian war, 'Monet studied almost daily in the National Gallery, with profound admiration, Turner's immortal masterpieces, finding in them confirmation of much previous research.' However, at this stage he clearly wishes to persuade his readers to accept the new art for its own intrinsic qualities, to sympathise with the struggle that the artists of the movement endured, and to share the shame he feels that the Impressionists have not been embraced as generously in his own country as they had elsewhere. To illustrate all three points, he extols the life and work of Monet in almost messianic terms, presenting him as the liberator and redeemer of landscape painters everywhere.

Having invoked the struggles and achievements of Monet to exemplify the inspiring qualities of Impressionist painting, Dewhurst declares his sorrow that in Britain the Impressionists had failed to meet with public approbation.

That a man of such remarkable and great accomplishment should be still comparatively

Path into the Woods (detail)
c 1894, oil on board
26 x 18cm
Private collection

Collecting the Milk (detail)
c 1894, oil on board
23 x 15cm
Private collection

unknown and almost wholly unappreciated in these isles, is an enigma that passeth understanding. Our transatlantic cousins, ever quick to perceive and encourage the good and the new, have for the past twenty years absorbed a large portion of the productions of the Impressionist school. 'Tis a very distinct loss, and one which in future will cost the nation dear to remedy, that none of our public galleries or museums contain a single specimen of French Impressionist work.[7]

Dewhurst does not rely solely on his appeal to the reader's intellect and humanity to win them over to the Impressionist cause. He also attempts to explain and justify their 'extra-ordinary' technical methods of production, and at the same time reassure the reader that these artists are not mere novice 'dabblers', but consummate draughtsmen with years of academic study and that they are in every way 'a fully equipped and intellectually capable body of men'. He explains that the Impressionists' great discovery, 'which alone renders painters for ever indebted to them', was that strong light dissolves tones and that the sun's rays tend to dissipate the prismatic tints, so that only by the juxtaposition of pure colours could sunlight effects be adequately represented. He goes on to discuss the Impressionist palette, explaining that they had renounced the use of all blacks, browns and ochre colours.

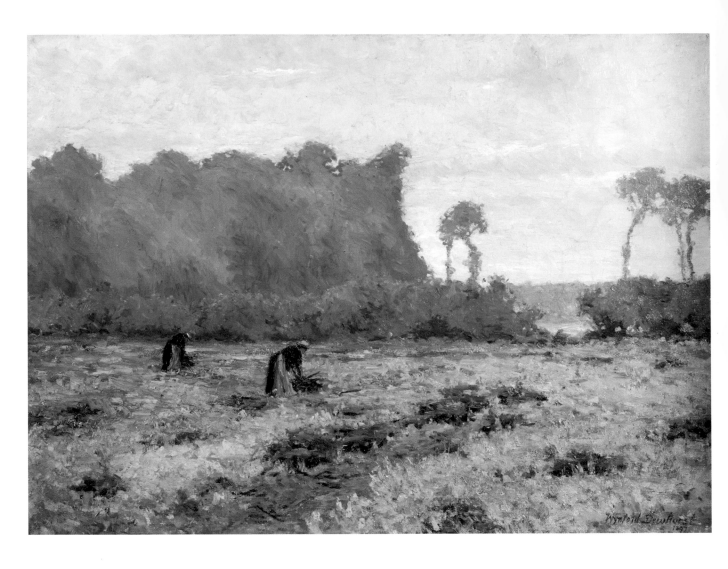

Woodgathering
1897, oil on canvas
58 x 80cm
Private collection

Flowering Gorse, Crozant
c 1906, oil on panel
18 x 26cm
Private collection

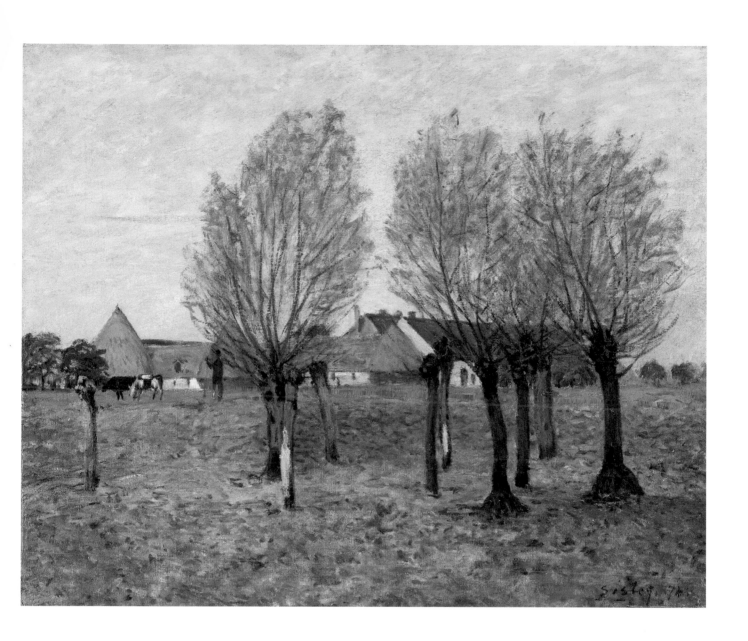

Alfred Sisley (1839-1899)
A Normandy Farm
1874, oil on canvas
49.6 x 59.8cm

Manchester City Galleries

In his customary fulsome language, Dewhurst concludes by saying that, as a result of their experiments with light and pigments and colours, some extraordinary results have been achieved and a legacy has been handed down to the benefit of painters everywhere.

> We see in Impressionist pictures an unconventionalised rendering of nature. We almost feel the vibration and palpitation of light and heat; they are fresh, radiant, and as sweet as a nosegay of spring flowers, and give us a marvellously deceptive appearance of open air and movement, which must be seen to be believed.[8]

It has to be remembered that at the time there was an unconcealed mistrust and jealousy among the English art establishment over all things French. Most aspiring young artists in the last quarter of the nineteenth century considered time on the Continent essential to 'round-off' their training, and Paris was still seen as the centre of the art world. Paris offered a choice of distinguished teachers at the free state-run École des Beaux-Arts, as well as numerous independent studios and many fine galleries and collections to study. Art education in Britain in the second half of the nineteenth century was in the grip of the 'South Kensington system'[9] and had become stagnant and uninspiring. Thus the Royal Academy felt under the threat of foreign invasion as young artists returned inspired and influenced by French modes and manners in painting. On a more rational level, the concern was about national identity and originality.

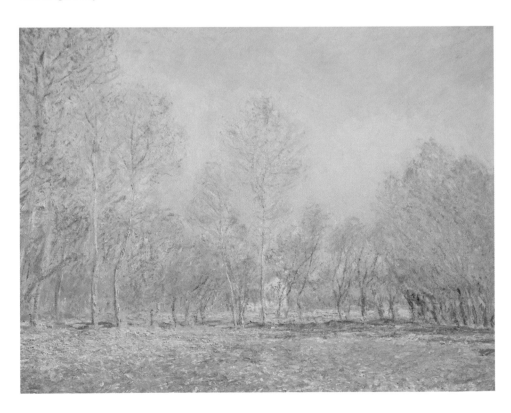

Claude Monet (1840-1926)
Spring in Giverny
1890, oil on canvas
90.8 x 106.7cm

Sterling and Francine Clark Art Institute,
USA/Bridgeman Images

Heath Pond, Leighton Buzzard
c 1899, oil on canvas
60 x 79cm

Buckinghamshire County Council

In his book, *French Art in Nineteenth-Century Britain*, Edward Morris has explained that, 'The enormous success of the Parisian teaching studios in attracting British art students for tuition there in the 1870s and 1880s greatly increased the hostility to French principles [and practices] among established British artists.'[10] In 1888 a spirited debate broke out in the *Magazine of Art* over the value of a French training and the consequent loss of national identity. It was a debate that was to preoccupy much of the English artistic community throughout the 1890s and into the twentieth century. The ageing Pre-Raphaelite, John Everett Millais, condemned English artists who 'persist in painting with a broken French accent'. He went on to say that English art students in Paris were 'seemingly content to lose their identity in their imitation of French masters, whom they are ... unable to copy with justice either to themselves or to their models'.[11]

The argument was stirred by the anglophile French art critic Ernest Chesneau. In a letter entitled 'The English School in Peril' to the *Magazine of Art* he wrote:

the more these young English painters succeed in assimilating the qualities, so antagonistic to their own, which are peculiar to the French school, the more they are striving to lose – and in fact are losing – the intrinsic qualities of their national birthright in order to gain a very doubtful advantage.[12]

The English realist artist George Clausen, who had studied in both Paris and Antwerp, replied to Chesneau's article later in 1888, and put the blame for the exodus of British painters to train in Paris on the poor state of art education at home:

the Englishman in Paris …though he gains much, yet also, undoubtedly, he does lose, to a greater or lesser extent, the distinctive characteristics of his country's art. And this is certainly a misfortune. But the blame, if any, must rest with those guardians of our art who for long years allowed the teaching in our art schools to be little better than a farce.[13]

There were defenders of the British art schools, but by this time most young British artists were deaf to their blandishments and only heard the siren voices drawing them towards Paris.

The young Dewhurst, struggling with his law studies in Manchester while successfully submitting illustrations to local journals, must have been aware of this controversy that was raging in artistic circles. He had set his heart on a career as an artist and like so many of his contemporaries saw Paris as the starting point for these ambitions.

In 1887, at the Manchester Royal Jubilee Exhibition, which Dewhurst would certainly have visited, there had been seen perhaps the largest collection of Victorian art ever assembled, without any contributions from the French and continental painting schools, and the debate about nationality in art was clearly foremost in the mind of several critics. Reviewing the exhibition, the art historian and, at the time, art critic of the *Manchester Guardian*, Walter Armstrong, claimed that it testified that the individuality of British art had not been lost under the pressure from continental influences. Another local critic, reviewing the exhibition in the *Manchester Courier*, declared with patriotic fervour:

There are many interesting results to be arrived at by the collection of pictures at Old Trafford. In the first place, the distinctive peculiarities of the English school of painting are made apparent; style of treatment, scheme of colour, and method of manipulation can now be seen and understood. To anyone with a knowledge of continental art, this show of pictures is invaluable; it speaks the tongue of the English race in language unmistakable; it illustrates the poetry and quietude of English thought; it shows an absence of sensational

trickery; and above all it avoids the ugliness and horrors of nature, and rather deals with the beauty and comeliness of creation.[14]

Although there was grudging agreement that the teaching methods in the French ateliers were superior, there was a continuing concern over the loss of national identity in the work of the artists trained in France. The sentiment was well summarised, with uncharacteristic pragmatism, by William Powell Frith, the eminent painter of genre scenes from Victorian life, such as *Derby Day* and *The Railway Station*, who, in an article on 'Art Education' in 1889, wrote:

> Let the student study the best examples of the English painters ... and while taking full advantage of the best training, whether in France or elsewhere, let him always remember that he is an Englishman, and endeavour to produce pictures which – unlike some of those by French-taught men – cannot be mistaken for foreign work.[15]

With the Francophobic climate that prevailed in the London art establishment, it is unsurprising that conservative views on Impressionism were predominant in England into the early years of the twentieth century. Most critics, and the tenor of the popular press, remained dismissive and disdainful. A review in 1889 of an exhibition of twenty pictures by Monet at the Goupil Galley in London reflects the disbelief and distrust that Impressionist pictures still generated in England:

> These strange and wayward productions ... will severely strain the faith of the ordinary British visitor. Whether good or bad, they are certainly unlike anything he has ever seen before in art; the question is whether they are equally unlike anything in nature.[16]

Monet, as leader of the new wave of French painters, was often singled out for particular scorn. One reviewer, finding three paintings by Monet at the Spring Exhibition of the New English Art Club in 1893, fumed: 'Claude Monet's art is the very anarchy of painting. It tramples upon the traditions of all schools. To pretend it is beautiful is to outrage aesthetics'.[17]

There were a few critics who sought to explain the new movement during these years. Frederick Wedmore, D.S. MacColl, George Moore and Frank Rutter all tried to 'educate' the public, justifying the methods of the Impressionists and contextualising their work. MacColl was a consistent admirer and advocate. In a 1901 review of an exhibition organised by Durand-Ruel at the Hanover Gallery in London, with the unsubtle, and perhaps provocative title of 'Pictures by French Impressionists and Other Masters', he wrote:

> The Hanover Gallery is making another attempt upon London with the French impressionists. London has been slow to bite during these thirty years; Monet is more familiar in American backwood towns than here, where we are still digesting cautiously a previous school down to the third and fourth generation...[18]

One can sense the writer's despair, which Dewhurst would most surely have shared. But all this widespread negativity surrounding French Impressionism only seems to have made him more determined to become its champion and gave him the incentive to launch his crusade. In the earlier articles of 1900 there is very little reference to the origins of Impressionism. Up to this point he seemed to be hoping that even the most confirmed sceptic would be swept along on a flood of florid language and hyperbole and find themselves unable to resist the premise that the Impressionists were sincere artists, who had suffered terribly from being so misunderstood, but who had now secured a rightful place in the history of art.

In 1903 there was a change in Dewhurst's strategy and he clearly decided to step up the rhetoric. In that year he wrote two seminal articles for *The Studio* which were

to become the foundation stones for his book and in fact carried the same title as the book, which was published in the following year - *Impressionist Painting: Its Genesis and Development*. In these articles he spelt out his belief that Impressionism owed its origins to the English romantic painters of the early years of the nineteenth century, in particular Constable, Turner and Bonington. Therefore, in embracing and adopting Impressionism, English art was merely receiving back from France 'an idea she had, as it proved, but lent'. It was an attempt by Dewhurst to neutralise, once and for all, the argument that British artists who went to Paris and took up with Impressionism, were losing their national identity. How could national identity be lost if Impressionism was essentially an English creation?

In his first *Studio* article of 1903 Dewhurst wastes no time in laying out his argument. In the second paragraph he writes:

> It is my object to show that the Englishmen who painted in the methods of the French impressionists, and were frequently charged with being mere imitators, as a matter of fact merely brought back their own, and carried on the traditions and discoveries of their most honoured Academicians at the most brilliant period in the history of the Royal Academy.[19]

He declares that Constable, Turner and Bonington were the true pioneers and originators of Impressionism, but sadly at the time none of their own countrymen built on the foundations they had provided.

> No British artist ... fully grasped the significance of the work of these men, nor to have profited by their valuable discoveries. They were evidently too much in advance of their time, and the idea went abroad for cultivation and fruition, like many another good thing germinated on these shores.[20]

Dewhurst goes on to explain how the technical methods of Impressionism compare with those of his British 'pioneers'. Firstly, he refers to the practice of painting and finishing pictures entirely out of doors - *en plein air*. Although artists had long painted out of doors to create preparatory sketches, or studies, before the nineteenth century, finished pictures would not have been created in this way. Constable and Turner pioneered this practice in order to capture some beautiful atmospheric effects, or *coup de soleil*, as they saw them unfold. Painting *en plein air* was an important step in the development of Naturalism. It was taken up by the Barbizon School of painters in France in the mid-nineteenth century and later became fundamental to Impressionism. The development of paints in tubes and light portable easels had enabled painters to work out of doors more easily. He explains how the Impressionists had 'purified and simplified' their palette, discarding blacks, browns, ochres and muddy colours generally and that they had replaced these with some new and brilliant ones, 'the results of modern

chemical research', and thus were able to attain a much higher degree of luminosity.

Continuing his analysis of techniques, Dewhurst states that Turner and Constable were experimenting, 'long before the advent of these Frenchmen,' with placing side by side on the canvas, spots, streaks or dabs of more or less pure colour in accordance with certain scientific principles. He instances Constable's large work, *The Opening of Waterloo Bridge*, in which 'a full-charged brush of pure white' is dragged over the surface to produce the illusion of the vibratory effect of brilliant light, a technique often used by the Impressionists, and records that when it was first seen by the press and public it was regarded 'as a bad joke, called a snowstorm, and ... the creation of a disordered brain, etc. Yet today it finds an honoured place in the Royal Academy and justifies itself in the eyes of all beholders.'[21]

Dewhurst says that the impressionist painter is never so happy as when recording some wonderful atmospheric effect and that Turner shared this emotion 'as many a fine canvas proclaims'. 'What then have the Frenchmen done to justify our admiration?' he asks, and then provides the answer, 'to them belongs the great

John Constable (1776-1837)
The Opening of Waterloo Bridge
1819-32, oil on canvas
134.6 x 219.7cm

Tate Collection/Bridgeman Images

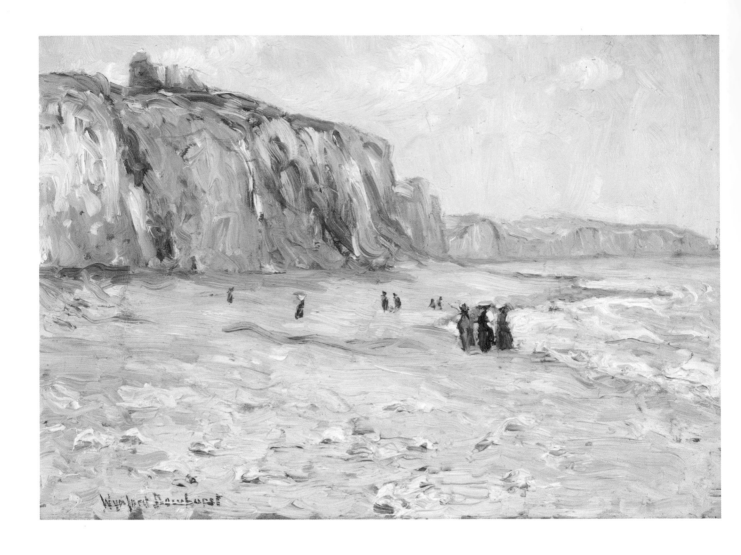

La Plage, Dieppe
c 1900, oil on board
18 x 25.7cm

Private collection

Walter Richard Sickert
(1860-1942)
Dieppe
c 1885, oil on panel
22.5 x 35.3cm

Manchester City Galleries

Richard Parkes Bonington
(1802-1828)
Beached Vessels and Wagon, near Trouville
c 1825, oil on canvas
37.1 x 52.4cm

Yale Center for British Art,
Paul Mellon Collection

merit of having perceived the value of the Englishmen's discovery, of having revived its practice, [and] of having carried it to its logical conclusion, whilst grafting on to Constable and others, suggestions from Japanese art and from that of their own countryman, Corot'.[22]

When his book was published in 1904 Dewhurst openly admitted in the preface that it was an amalgam of his previously written articles and he thanked the editors for use of the material. Even so, the publication of the book was an important event as it was the first survey of the French Impressionists to be written and published in English. In it, Dewhurst expands his argument to the point of exaggeration, gives biographical details and anecdotal material for over 25 artists and adds useful appendices on the scientific methods of Impressionism, sales and prices and prominent

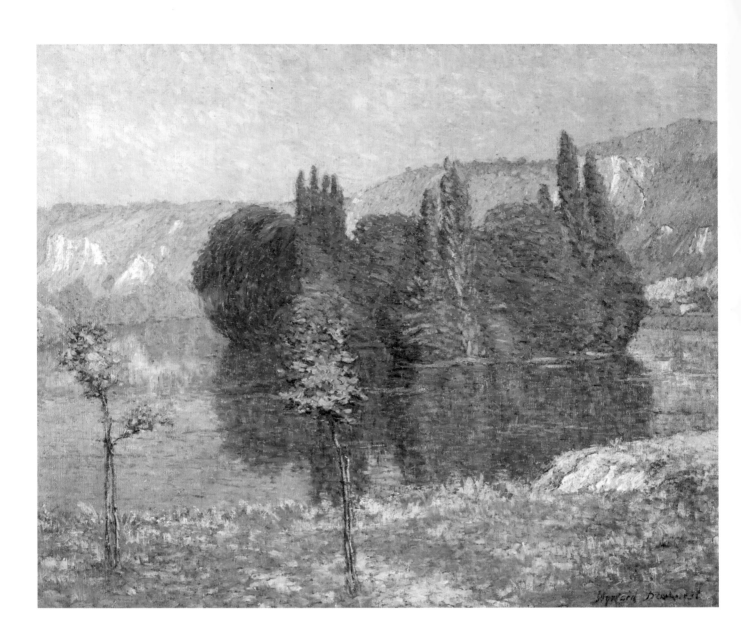

The Seine at
Les Andelys (detail)
c 1903, oil on canvas
72 x 99cm

Private collection

collectors. However, due to his enthusiasm for the cause there is a distinct lack of any critical element, or as one reviewer in the *Burlington Magazine* put it, 'Mr Dewhurst is perhaps rather more appreciative than critical ... This want of proportion is a serious fault, for it makes the book less valuable than it might otherwise have been. It is special pleading rather than impartial judgement.'[23]

In the first chapter, 'The Evolution of the Impressionistic Idea', Dewhurst reiterates his central thesis that during the nineteenth century, 'French artists simply developed a style which was British in its conception'. Or, put even more simply, 'British artists showed the way in the fight against tradition and form, which resulted in the School of Barbizon, and its great successor, the School of Impressionism.' He makes the claim, considered contentious by some, that during the same period English art reached its nadir. He deplores the fact that the genius of Constable, Turner, Bonington and some members of the Norwich School was not recognised or taken up by British artists. He asserts that British art drifted into what art historian Sir John Rothenstein was later to call a 'stagnating backwater'[24] and became dominated by, 'pictures to amuse nursery maids and their charges' – as one reviewer of the 'Art Treasures of Great Britain' exhibition, held in Manchester in 1857, expressed it.[25]

In support of this argument Dewhurst then writes what are possibly the two most important paragraphs in his book, and in which its whole raison d'être is encapsulated in less than two hundred words:

> It was not the first brilliant idea, which evolved in England, has had to cross the Channel for due appreciation, for appreciated it certainly was not in the country of its origin. As the genius of the dying Turner flickered out, English art reached its deepest degradation. The official art of the Great Exhibition of 1851 has become a byword and a reproach. In English minds it stands for everything that is insincere, unreal, tawdry and trivial.

> The group of Pre-Raphaelites, brilliantly gifted as they were, worked upon a foundation of retrograde mediaevalism. And, as the years followed each other, English art failed as a whole to recover its lost vitality. Domestic anecdote formed the product of nearly every studio. The false Greco-Roman convention of Lord Leighton luckily had no following. Rejuvenescence came from France in the shape of Impressionism, and English art received back an idea she had, as it proved, but lent.

Dewhurst explains that the Impressionists were not a 'school' in the sense the term implies a teacher and pupils. On the contrary, they were independent co-workers, banded together by friendship, moved by the same sentiments, each one striving to solve the same aesthetic problem. However, he concedes that there were two predominant figures who were responsible for the development and ultimate success of Impressionism – Edouard Manet and Claude Monet. He notes that after

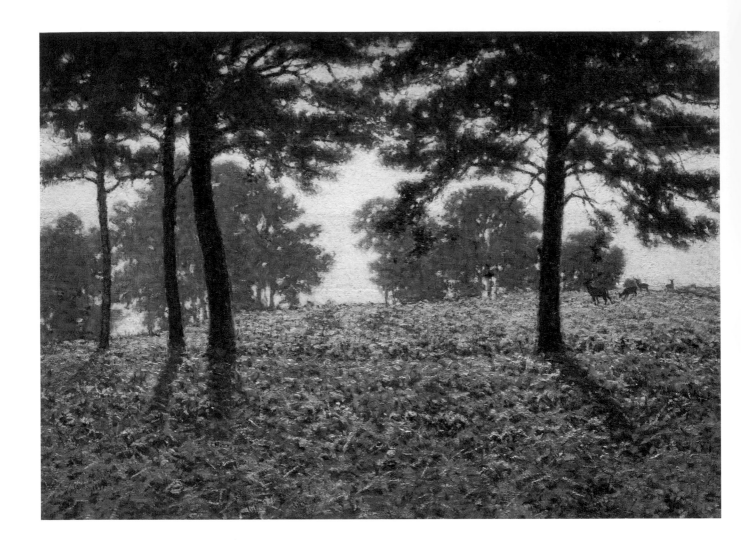

**Evening Shadows,
Stockgrove Estate,
Leighton Buzzard**
1899, oil on canvas
72 x 99cm

Private collection

Jean-Baptiste-Camille Corot
(1796-1875)
Sunset: Figures under Trees
oil on canvas
33.8 x 43.8cm

Manchester City Galleries

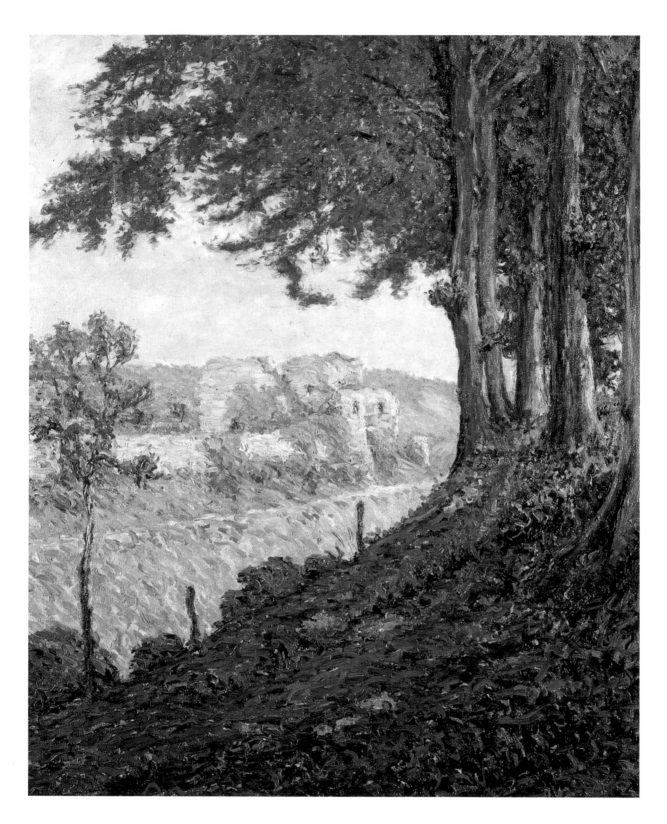

Château d'Arques, Dieppe
1908, oil on canvas
91.4 x 73.5cm

Private collection © Richard Green Galleries

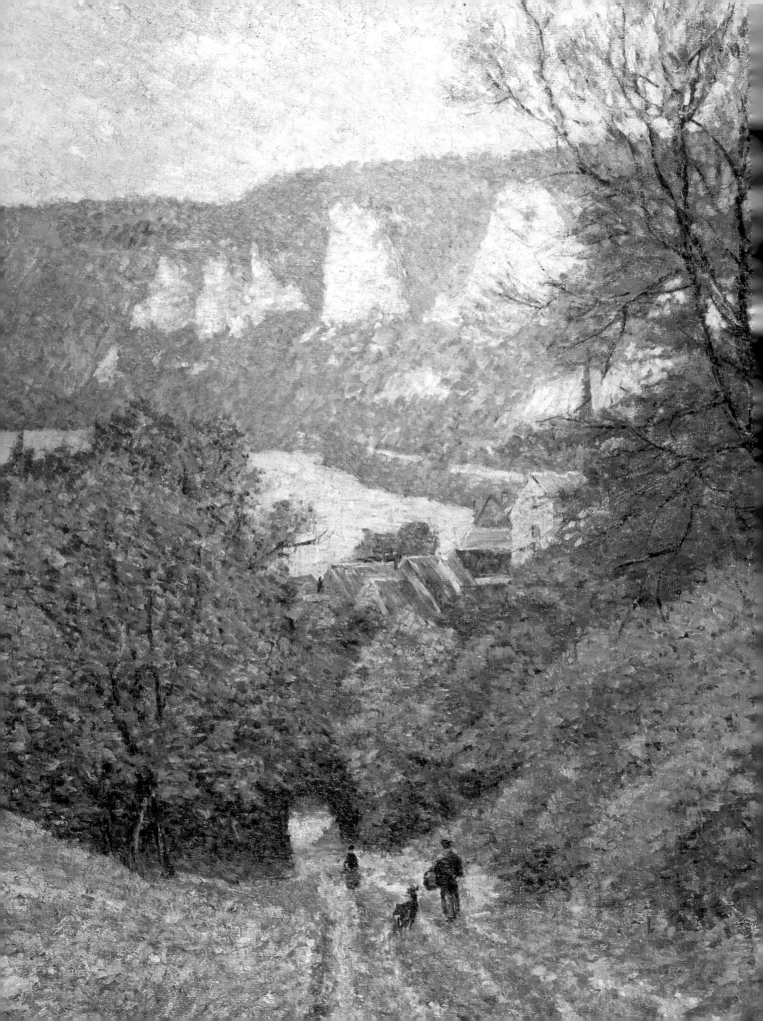

Manet's death in 1883, Monet, with his originality and authority as an artist, became recognised as head of the group. Then Dewhurst reiterates his central theme by remarking that, 'Claude Monet is doubly indebted to English art. Profoundly moved by Turner, whose works he studied first hand in England, he also traces an artistic descent through Jongkind and Boudin from Corot, who caught the methods of Constable and Bonington.'

He comments that, although they are such an eclectic band of fellow-travellers, it is possible to separate the Impressionist painters into distinct groups, and that is exactly how the book is laid out, with biographical details and critical comments on the work of artists grouped under selected chapter headings. As well as the core founders of the group, many of those included are Dewhurst's own contemporaries, who were too young to have exhibited at the eight Impressionist exhibitions 1874-1886, while others would not today be considered as true Impressionists.

In his chapter on Pissarro, Renoir, Sisley and Guillaumin, Dewhurst's admiration for the work of Camille Pissarro, who died a year before the book was published, is clear, in spite of the *contretemps* he had with the artist over the origins of Impressionism. He says Pissarro was a man of commanding personality, whose art possessed a lively vitality and sentiment that will 'assure a lasting respect and

admiration for his name'. He acknowledges Auguste Renoir as one of the masters of the Impressionist movement, but says that he 'is above all a painter of women and children, and his creations in this genre glow with the sure fire of genius'. However, Dewhurst clearly does not have regard for Renoir as a landscape painter, saying, 'Many find it hard to appreciate his landscapes, considering them to be thin, of a greasy woolly texture, unatmospheric and lacking many of the qualities one looks for in such representations of nature.' He adds, 'the work of Auguste Renoir will always remain a battlefield for the critics'. Dewhurst's clear preference for artists who concentrate on landscape, like himself, is reflected in his comments on the work of Alfred Sisley, whom he calls a *paysagiste* 'pure and simple' who, in spite of demoralising poverty, 'left a legacy of some of the most fascinating landscapes ever painted'.

From his very personal observations about the work of each painter he reviews, one gains the clear view that Dewhurst sees Impressionism as largely being concerned with plein air landscape painting and the depiction of nature in its varying moods. This rather blinkered perspective is borne out by the fact that, to date, no examples of still life, urban living or portraiture have been revealed in his own work. One suspects it is Edgar Degas's subject matter which explains Dewhurst's cool reaction towards this artist. He places him in a chapter entitled 'The Realists' alongside artists such as Raffaelli and Toulouse-Lautrec, and questions whether he was a true Impressionist. He says of Degas, 'although always classed with the Impressionists, he stands apart from the recognised group. He has never endeavoured to transmit the impression of atmosphere, and work *en plein air* does not attract him.' Dewhurst acknowledges that Degas's work was popular and that he was technically brilliant as a draughtsman, but he asserts:

> Degas is a realist, and his subjects are for the most part exceedingly trivial in selection. After racehorses and ballet-dancers, he loves to depict buxom ladies of the lower classes engaged in personal ablution.

These comments probably tell us more about the assertive and somewhat prudish nature of Dewhurst than they do about the work of Degas.

Dewhurst continues with a chapter on 'Some Younger Impressionists', which includes men like Eugene Carrière, Auguste Pointelin and Maxime Maufra, a friend and painting companion who painted extensively in Normandy and in the Seine Valley. Another chapter is headed 'La Peinture Claire'. Among the painters included in this section is Emile Claus, whose work first inspired Dewhurst back in Bradford fourteen years previously. Claus had become leader of the 'Luminist' school in Belgium, a late flowering of Impressionism which devoted great attention to the effects of light. Also in this section are Henri Le Sidaner and Albert Besnard, French painters who

shared Claus's obsession with solving the 'mysteriously beautiful problems of light'. The fourth painter in this chapter is William Didier-Pouget, an exact contemporary and friend of Dewhurst's, who became famous and highly honoured for his paintings of the Dordogne and the Creuse Valley, where Dewhurst spent many happy hours painting alongside him. His paintings were considered 'Impressionist' at the time because they were luminous and bright, but in fact they were more finished and composed than most Impressionist work.

In his chapter on 'The "Women Painters"', Dewhurst points out that it is the first time in the history of art that women had played an active part in founding a new school. He singles out four artists in particular: Berthe Morisot, Mary Cassatt, Eva Gonzalès and Marie Bracquemond. He teeters on the edge of being patronising when he says, 'these women introduced into the stern methods of the early Impressionists a feminine gaiety and charm', but goes on to emphasise that collectively they had a strong influence on the other members of the group, and that, 'at times their talent touches genius'. He ends by saying proudly that, 'Modernity is the note of Impressionism, and that movement was the very first artistic revolt in which women took a prominent part.'

In an important chapter Dewhurst praises what he calls the 'little masters' of the transitional period in French art from 1830 to 1870 – painters like Jongkind, Boudin, Isabey, Daubigny, Troyon, Huet, Rousseau and others of the Barbizon community, who kept alive the flame lit by the English in the salons of the 1820s. He commends them as men of 'uncommon character, richly endowed with natural talents ... producing some wonderfully interesting pictures ... but never attaining the colour vibration of the Englishmen ... nor of Monet and his co-workers'. However, Dewhurst concedes that

Maxime Maufra (1861-1918)
Springtime at Lavardin
1907, oil on canvas
65 x 80.6cm

Manchester City Galleries

Harvest: Sunlight Effect
c 1913, oil on canvas
79 x 99cm

Private collection
[Exhibited RA 1914. No.257]

The Shepherd
c 1908, pastel
23.5 x 32.5cm

Private collection

Sheep Grazing beneath Flowering Apple Trees
c 1902, oil on canvas
60.9 x 85.7cm

Private collection © Bonhams 1793 Ltd

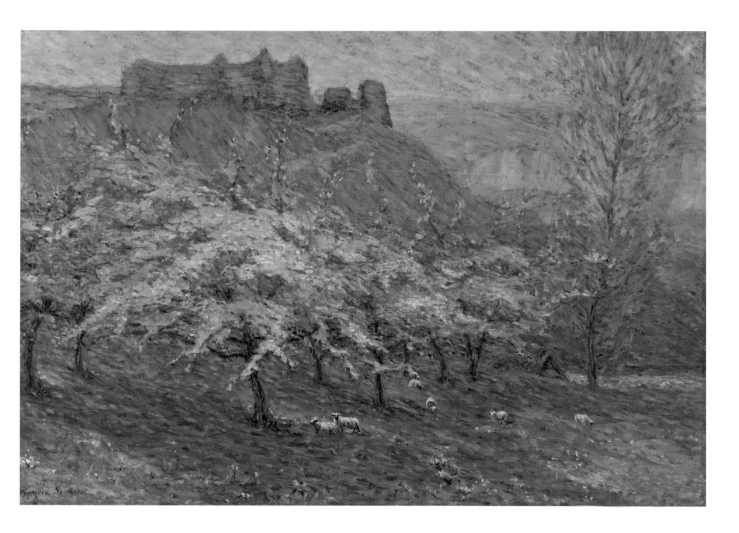

any history of the development of Impressionism and of *plein air* painting would be incomplete without some reference to the part played by these 'intermediary men'.

He singles out Boudin as the leading member of this group; Boudin, whom Corot referred to as *'le roi de ciels'*, was the master to whom Monet owed so much in the early stages of his artistic life. However, Dewhurst says that 'pupils of originality do not develop on parallel lines to their teachers and Monet was no exception'. Contentiously, he repeats his belief that after his visit to London in 1870, Monet 'flew off at a tangent' and was *élève de Boudin* no longer. Elsewhere in the book he relates in more detail the events of that year, when Monet and Pissarro were in exile in London, and this is where he starts to build into almost mythical status the story of how the two artists were deeply moved and influenced by seeing the work of Turner in the National Gallery. It was an event which, according to Dewhurst, changed the whole course of Western art.

The importance he gave to this happening was to lead him into trouble with the French Impressionists themselves, who, although acknowledging their debt to the English landscape painters, pointed to other 'home grown' influences on their work. But Dewhurst was a man with a mission and he was determined to represent the Frenchmen's enforced stay in London as a key event in the development of Impressionism, resulting for Monet and Pissarro in a damascene conversion. It was his insistence on this deeply held belief that was to discredit his book in the eyes of some future art historians.

Notes

1 Wynford Dewhurst, 'Picturesque France', *The Artist*, March, 1900, pp. 365-7.

2 Kenneth McConkey, *Impressionism in Britain*, London, 1995, p. 82.

3 Kenneth McConkey, *British Impressionism*, London, 1989, pp. 140 and 144.

4 Wynford Dewhurst, 'What is Impressionism?', *Contemporary Review*, Vol. XCIX, 1911, p. 300.

5 Wynford Dewhurst, 'Claude Monet - Impressionist', *Pall Mall Magazine*, June, 1900, p. 209.

6 See Introduction, note 2.

7 Wynford Dewhurst, 'Claude Monet - Impressionist', *Pall Mall Magazine*, June, 1900, p. 210.

8 Ibid., p. 217.

9 For a good description of the system, see Quentin Bell, *The Schools of Design*, London, 1963. See also Jeanne Sheehy, 'The Flight from South Kensington: British Artists at the Antwerp Academy 1877-1885', *Art History*, March 1997, pp. 124-53. Also, Anna Gruetzner, 'Two Reactions to French Painting in Britain', in *Post-Impressionism* (Exhibition Catalogue), London, 1979, pp. 178-82.

10 Edward Morris, *French Art in Nineteeth-Century Britain*, Yale, 2005, p. 283.

11 Ibid., p. 285.

12 Ernest Chesneau, 'The English School in Peril, a letter from Paris', *The Magazine of Art*, November, 1887, pp. 25-28.

13 George Clausen, 'The English School in Peril: A Reply', *The Magazine of Art*, 1888, pp. 222-4.

14 Edward Morris, op. cit., p. 285.

15 Ibid., p. 286.

16 *The Times*, 18 April 1899, p. 8 (unsigned review).

17 *National Observer*, 15 April 1893, p. 542 (unsigned review of NEAC exhibition).

18 D.S. McColl, 'Impressionists in London', *Saturday Review*, 26 January, 1901, pp. 106-7.

19 Wynford Dewhurst, 'Impressionist Painting: Its Genesis and Development', *The Studio*, April 1903, p. 159.

20 Ibid., p. 159.

21 Ibid., p. 160.

22 Ibid., p. 160.

23 *Burlington Magazine*, June, 1904, pp. 320-1.

24 John Rothenstein, *An Introduction to English Painting*, London, 1933, p. 113.

25 *Quarterly Review*, vol. 1857, p. 197.

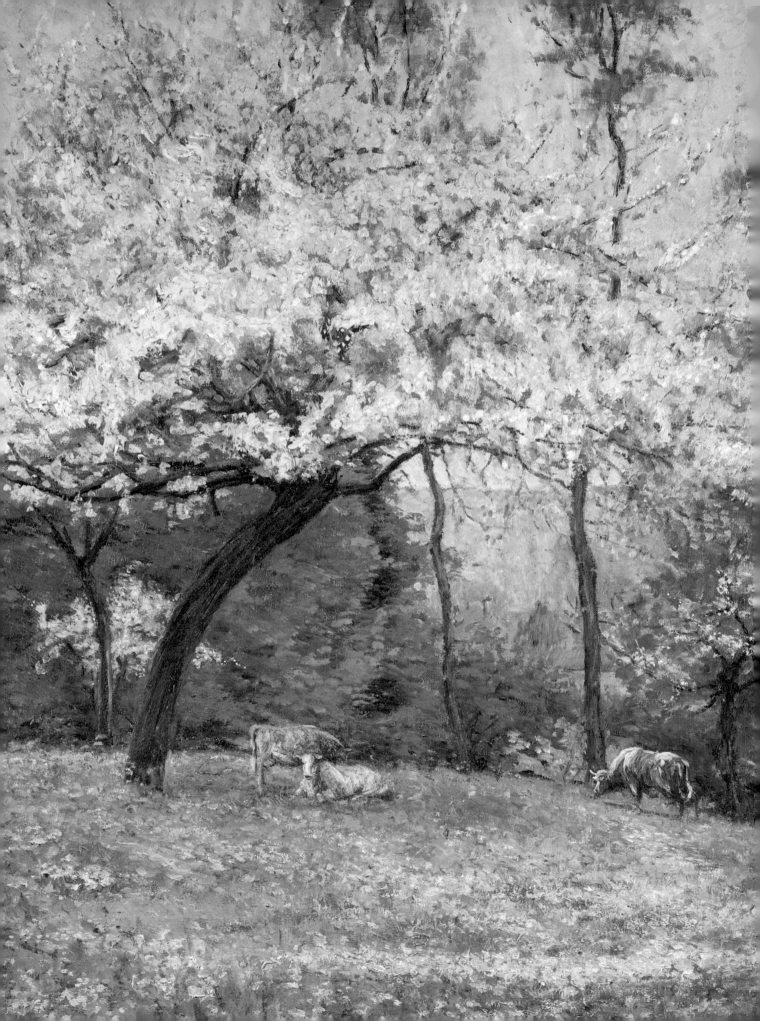

2. The Origins of Impressionism

Facts and fiction

Indirectly, Impressionism owes its birth to Constable; and its ultimate glory, the works of Claude Monet, is profoundly inspired by the genius of Turner ... It cannot be too clearly understood that the Impressionistic idea is of English birth.

Wynford Dewhurst (1904)

This Mr Dewhurst understands nothing of the Impressionist movement ... Mr Dewhurst has his nerve!

Camille Pissarro (1903) [1]

The art critic George Moore wrote in 1888, 'The history of Impressionist Art is simple ... the Turners and Constables came to France, and they begot Troyon, and Troyon begot Millet, Courbet, Corot, and Rousseau, and these in turn begot Degas, Pissarro, Madame Morisot, and Guillaumin.'[2] If only the history of Impressionism was as simple, or undisputed, as George Moore suggests. It is certainly true that in 1824 John Constable's *The Hay Wain* was the talk of Parisian society. How this came about is a fascinating story, and central to Wynford Dewhurst's belief that the origins of Impressionism were English.

In the first chapter of his book, Dewhurst states that although the revolution of 1793 changed the whole face of France both politically and socially, 'it failed to emancipate the twin arts of painting and literature ... and nearly forty years elapsed before the new spirit completely broke through the barriers set by a past generation'.

In the summer of 1821, the French painter Théodore Géricault, who was leader of the emerging Romantic movement in French art, was in London. After a visit to the Royal Academy Summer Exhibition, which featured the first public showing of *The Hay Wain*, he wrote to an artist friend in Paris:

The Exhibition just opened has again confirmed me in the belief that colour and effect are understood and felt only here [London]. You cannot imagine the beauty of this year's portraits and of many of the landscapes and genres'.[3]

On returning to France in the autumn of 1821 Géricault told the painter Eugène Delacroix that Constable's *The Hay Wain* had 'astounded and moved' him. When Delacroix saw the picture in the gallery of a Parisian dealer in 1824, two months

Springtime in Normandy
1898, oil on canvas
72 x 59cm

Private collection

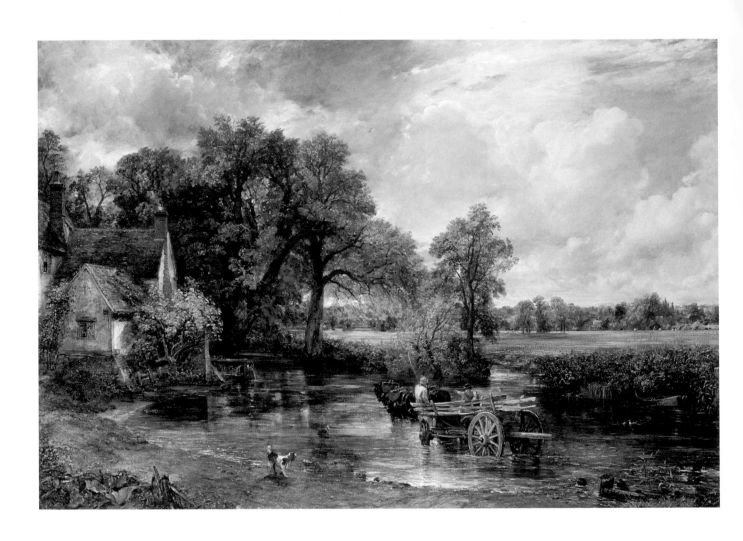

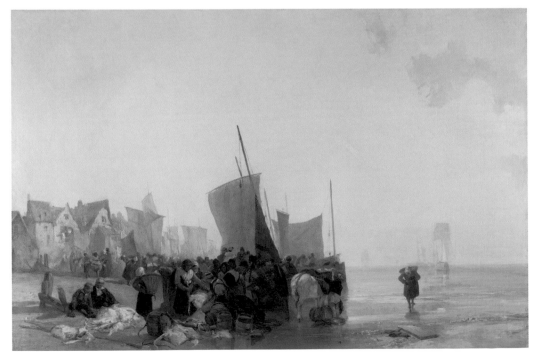

before the Salon, he was equally inspired by Constable's work and rushed back to his studio and made changes to his great work *The Massacre at Chios*. He wrote in his journal for 19 June 1824, 'Ce Constable, me fait un grand bien.' His view of Constable's contribution to the Romantic movement and his own artistic development was clearly undiminished by the passing of time, as 34 years later he wrote to a friend:

> Constable, an admirable man, is one of England's glories. I have already told you about
> him and the impression he made on me when I was painting the Massacre at Chios.
> He and Turner were real reformers. They broke out of the rut of traditional painting.
> Our school, which today abounds in men of talent in this field, profited greatly by their
> example.[4]

To understand why Géricault and Delacroix, along with others of their countrymen, were so excited and enthusiastic about English art, and that of Constable in particular, we need to examine the state of French art after the Napoleonic Wars. In 1815 French landscape painting had for 30 years been stereotyped and sterile. Throughout this period, 'classical' landscape, history painting and portraiture had reigned supreme dominated by the work of Napoleon's favoured painter Jacques-Louis David and his pupil Jean-August-Dominique Ingres.

However, in the post-war years, English fashion in matters of dress and manners gained ground led by the bourgeoisie and the remaining aristocrats, who had returned from exile. To French artists of Géricault's generation, discontented with David's predominance and that of the conservative academicians, London appeared to offer a more exciting and stimulating alternative and it was recognised that *le style anglais* had something unique to offer. For young progressive French artists, a visit to London became a rite of passage and they responded positively to the technical freedom they saw in British art, both in oil and watercolour. Art historian William Vaughan has said: 'Never before, or since, has British painting played such a critical role in European culture… In the 1820s British painters were widely fêted by those interested in reforming the grand French tradition by introducing greater naturalism and modernity.'[5] It was a time when the work of Constable, Lawrence, Bonington and Turner was considered radical and progressive.

The result of the appearance at the 1824 Paris Salon of *The Hay Wain* and *A View on the River Stour* was public acclaim such as Constable had never experienced in his own country. So great was the clamour to see his pictures that they had to be removed to a place of honour in the principal room. Misunderstood and overlooked at home, ironically, the 48-year-old Constable had become the darling of the young French 'Romantics'. However, most of the French critics were as steeped in classicism and convention as their English counter-parts. In spite of the fact that Constable had

become the talk of Paris, many critics were angry at the English interloper, and angry at French taste for admiring his work. Others were critical of the commonplace nature of the scene depicted in *The Hay Wain*. The critics, used to the action and narrative of history painting, could not understand the lack of a grand or patriotic subject. One complained:

> Monsieur Constable is as true as a mirror, but I should like the mirror to reflect a magnificent site, such as the valley of the Grande Chartreuse at Grenoble, and not a hay cart crossing a canal of stagnant water.[6]

Another critic attacked Constable's work as an undesirable influence on young painters who would be seduced from the allegiance they owed to Poussin. Here we see criticism which exactly foreshadows that thrown at the British followers of Impressionism sixty years later by the English art critics - lack of finish, mundane motifs and the danger of artists losing their national identity.

The 1824 Salon, which later became known as the 'British Salon' was a triumph for the English painters who were fêted and honoured with three gold medals of excellence. John Constable received his for *The Hay Wain*, Richard Parkes Bonington for *A Fish Market near Boulogne* and the third was won by Anthony Vandyke Copley Fielding for nine small watercolours, a medium which was often referred to by the French as the 'British Medium'. In addition, the Legion d'Honneur was awarded to the portraitist Sir Thomas Lawrence, who was then president of the Royal Academy in London. In all there were 44 English paintings on display, including works by Varley, Prout, Cox and Cotman.

John Constable (1776-1837)
View from Hampstead Heath, Looking towards Harrow
1821, oil on canvas and paper
25 x 29.8cm

Manchester City Galleries

At the Salon of 1827 Constable exhibited for the last time and Dewhurst remarks on a curious omen for the future; 'between the frames of Constable and Bonington was hung a canvas by a young painter who had never been accepted by the Salon before. His name was Corot, and he was quite unknown.' He might have added that this was the great Camille Corot who much later recalled seeing a landscape by Bonington in the window of a Paris gallery in 1821 and expressed sentiments that must have been shared by many young painters who saw the work of the English artists at the Salons of 1824 and 1827:

> No one thought of landscape painting in those days ... the artist had captured for the first time the effects that had always touched me when I discovered them in nature and that were rarely painted. I was astonished. His small picture was for me a revelation. I discerned its sincerity and from that day I was firm in my resolution to become a painter.[7]

Although Bonington was overshadowed by Constable in the 'British Salon', he is an important figure in the development of the Romantic movement in France. English by birth, in 1818, when he was 16, his father moved his business and the family to Paris. His Anglo-French nationality helped him to become an intermediary between the English and French schools of Romantic painting. He was immensely talented, and the facility with which he worked in both oils and watercolour amazed his contemporaries. He befriended the young Delacroix, who became an ardent admirer of his work. They travelled to England together in 1825 and shared a studio in Paris for two years. Delacroix said of him later, 'no one in the modern school ... possessed the lightness of execution which makes his works, in a certain sense, diamonds, by which the eye is enticed and charmed independently of the subject, or of imitative appeal'.[8] Sadly, Bonington died of consumption in 1828 at the age of 26, so his full potential was never realised. But to Dewhurst he was one of the Englishmen who helped to change the course of art history and as such quite definitely qualified as a prophet of French Impressionism.

Whereas Bonington was better known and acclaimed in France than in England in 1824, the reverse was true of J.M.W. Turner, who had established himself at home as an Academician of national standing and whose versatility and invention were highly praised. However, in France he was not yet a major influence. It was his latter period, from around 1830, when he was producing extraordinary visual fantasies, that caught the imagination of the late Romantics. This work was too personal and idiosyncratic to be copied, but it was the techniques employed, the effects of light and colour achieved and the emotion contained within them, which inspired the fledgling Impressionists in 1870 when they saw this work in the National Gallery in London.

It is from this point, according to Dewhurst, that Turner became recognised and adopted as a proto-Impressionist.

So what did Constable, and the other English artists, give to French art, or indeed European art, in the nineteenth century? As we have seen, after the Napoleonic period there was already a movement underway in French art to release it from the straitjacket of classicism. Romanticism and the desire for more freedom in art had already taken root among a number of French artists. What Constable gave them was technique and encouragement. An article on *The Hay Wain* in the *Burlington Magazine* in 1933 said, 'Constable was less an example more of a liberating force whose impact, though momentary, gave powerful impetus to an incipient revolutionary movement … What they [French painters] chiefly got from Constable was licence for an impressionistic freedom of handling combined with a bracing sense of contact with the world out of doors'.[9] Kenneth Clark makes a point, which seems to support Dewhurst's thesis, when he says in his book *Landscape into Art* (1949) that Constable's influence in England was practically nil; whereas in France it was immense. He explains, 'It did not induce Delacroix to paint willows and cottages, but to repaint his *Massacre at Chios* in a freer more colouristic technique.'[10] Patrick Noon, in the catalogue for the exhibition 'Constable to Delacroix' at the National Gallery in London (2003), reiterates Dewhurst's simple message, when he asserts that British Romanticism was a 'cardinal force in the evolution of French art' and that 'during the decisive decade of the 1820s, a profound engagement between two previously unsympathetic schools of painting resulted in innovations that would radically affect the course of modern art in Western Europe'.[11] So when Géricault viewed *The Hay Wain* in London in 1821 he saw a vision of the future, not an end in itself, but a vision on the road to the future, something new and challenging, different, radical, romantic and innovative in its technique.

The irritable remark by Camille Pissarro at the head of this chapter was made in a private letter to his son, Lucien, in May 1903 after he had seen Dewhurst's article in *The Studio* of April that year. It is both unfair and disingenuous. While preparing his articles for *The Studio* Dewhurst wrote to a number of associates in the Impressionist group seeking their thoughts about the development of Impressionism. In November 1902 Pissarro wrote back:

> In 1870 I found myself in London with Monet … We visited the museums. The water-colours, and paintings of Turner and Constable, the canvases of Old Crome, have certainly had influence upon us. We admired Gainsborough, Lawrence, Reynolds, etc., but were struck chiefly by the landscape-painters, who shared more in our aim with regard to 'plein air,' light, and fugitive effects.[12]

Pissarro was probably taken aback by the authority and emphasis that Dewhurst put on these comments, which he interpreted as support for his underlying hypothesis. Pissarro wrote in a fit of patriotic anger to his son, Lucien:

This Mr Dewhurst understands nothing of the impressionist movement, he sees only a mode of execution and he confuses the names of the artists … He says that before going to London [in 1870] we [Monet and Pissarro] had no conception of light. The fact is we have studies which prove the contrary. He omits the influence which Claude Lorrain, Corot, the whole eighteenth century and Chardin especially exerted on us … Turner and Constable, while they taught us something, showed us in their works that they had no understanding of the analysis of shadow, which in Turner's painting is simply used as an effect, a mere absence of light. As far as tone division is concerned, Turner proved the value of this as a method, among methods, although he did not apply it correctly … It seems to me that Turner, too, looked at the works of Claude Lorrain, and if I am not mistaken one of Turner's paintings, Sunset, hangs next to one of Claude![13] Symbolic, isn't it? Mr Dewhurst has his nerve.[14]

He writes to Dewhurst in rather more polite and calm terms:

I have read with great interest your article. I do not think, as you say, that the Impressionists are connected with the English school, for many reasons too long to develop here. It is true that Turner and Constable have been useful to us, as all painters of great talent have; but the base of our art is evidently of French tradition, our masters are Clouet, Nicolas Poussin, Claude Lorrain, the eighteenth century with Chardin, and 1830 with Corot.[15]

Dewhurst prints Pissarro's rebuke in his book but uses it to his advantage by remarking, 'the artists who have profited most by the valuable example of our men of genius seem least inclined to acknowledge their debt. This statement is somewhat at variance with facts as we know them, and does not agree with several letters from Pissarro in the writer's possession'. It seems lines were being drawn up on either side of the Channel in defence of national self-esteem and identity. Dewhurst was attempting to prove to artists, critics and sceptics at home that Impressionism was in essence an English phenomenon, while Pissarro, perfectly happy to acknowledge an indebtedness to Turner, did not want his countrymen to think he had lost sight of its 'home grown' antecedents and roots. Unfortunately, we do not know how Pissarro would have reacted to Dewhurst's book, or how the *contretemps* between the two men would have played out, as Pissarro died in November 1903, six months before the book was published.

However, there is plenty of evidence that Pissarro not only admired Turner,

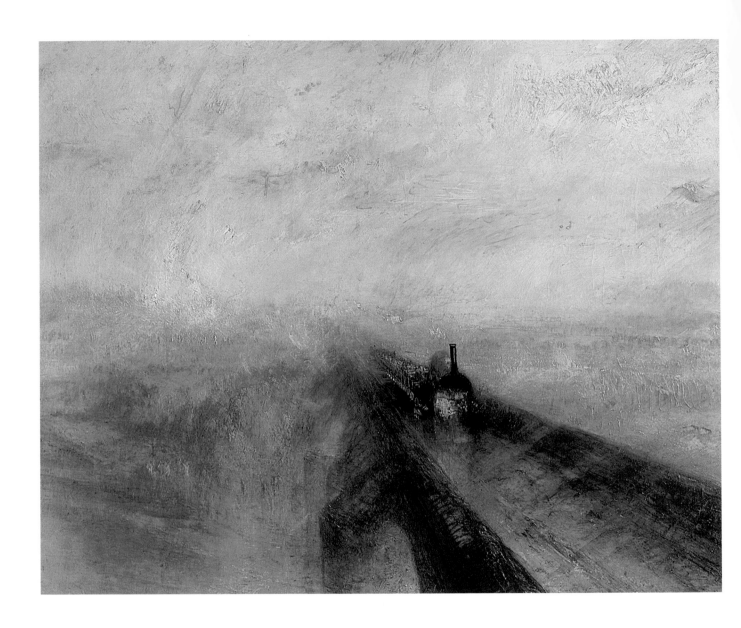

Joseph Mallord William Turner
(1775-1851)
Rain, Steam and Speed
1844, oil on canvas
91 x 122cm

National Gallery, London, UK
/Bridgeman Images

John Constable
(1776-1837)
Rainstorm over the Sea
c 1824-8, oil on paper laid
on canvas 23.5 x 32.6cm

Royal Academy of Arts, London

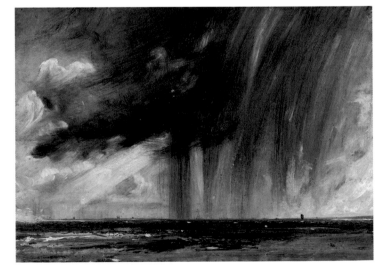

but recognised the debt that all the Impressionists owed to him. Perhaps his most public affirmation was in an article in *The Artist* of June 1892 when he was reported as saying, 'It seems to me that we are descended from the English Turner. He was perhaps the first to make his colours shine with natural brilliancy. There is much for us to learn in the English school'.[16] Turner's name occurs constantly in Pissarro's correspondence and it is clear that the English painter is a recurring influence on his work. In 1883 when his son Lucien was in London learning English, he wrote to him, 'you have seen the Turners but you don't mention them. Can it be that the famous painting *The Railway* ... did not impress you?'[17] The reference here is to Turner's *Rain, Steam and Speed*, which John Gage has said became a sort of talisman to the Impressionist group and, indeed, Félix Bracquemond's etching after it was included in the first Impressionist exhibition in 1874.[18]

Later in 1883, Pissarro was painting in Rouen and wrote to his son in London asking him to copy a Turner watercolour of Rouen and send it over to him. In 1888, again in a letter to his son, Pissarro vents his frustration about the absence of pictures by Turner in the Louvre, 'Isn't it senseless that there are no Turners.'[19] Ten years later he advised the young Matisse to look at the Turners while in London on his honeymoon.[20] There seems to be little doubt that Turner's work and achievements meant far more to Pissarro than he was prepared to share with Dewhurst. But from his public utterances alone Dewhurst seems justified in thinking Pissarro's debt to the English painter was considerable.

Unperturbed by Pissarro's put-down, Dewhurst pressed on with the publication of his book. He was able to enlist the support of Emile Claus and Maxime Maufra, two contemporary artists painting in the Impressionist style, to endorse his standpoint. Claus, now in his fifties, was the Belgian 'luminist' painter who had first inspired the young Dewhurst when he saw his work in the exhibition of the Maddocks collection in Bradford. He replied, obligingly, to Dewhurst's request for a comment by saying that it was in England, above all other countries, where light and life in painting were born, and adding; 'I have all too quickly glanced at the Turners and Constables of London, nevertheless it was a revelation to me, and those great artists Monet, Sisley and Pissarro continue simply what that great giant Turner discovered.'[21]

Maxime Maufra was a businessman turned painter who had had a highly successful one-man show at the Durand-Ruel gallery in Paris in 1901, after which one critic said of his work, 'this is complete Impressionism'. Dewhurst had clearly made his acquaintance, as he writes:

Some time ago the writer was painting by the edge of the Seine in company with Maxime Maufra, and the artist recounted the origins of his Impressionistic tendencies.

[He said] 'I am directly influenced by Turner and Constable. I admired and studied their works whenever it was possible during the time I spent as a commercial man in Liverpool twenty years ago. There is no doubt that Monet, Pissarro and others of that group, owe the greater part of their art to the genius of the great Englishmen, just as Delacroix and Manet were indebted in a previous generation.[22]

Interestingly, although he thanks Claude Monet, Mary Cassat, Max Liebermann (German), Alexander Harrison (American), Paul Durand-Ruel (dealer) and George Petit (dealer) and indeed, 'all the artists illustrated' in the book, for permission to use the photographs of their works, he clearly fails to elicit any further comments or endorsements from the leading practitioners of Impressionism.

It is at this point in the book, when discussing the 'Evolution of the Impressionistic Idea', that Dewhurst demonstrates that he is aware that within the canon of French art there were forerunners to whom the aspiring Romantics, and later the Impressionists, could look with pride, and from whom they could gain instruction and inspiration. He says: 'Watteau, in particular, was the first to catch the sunlight ... Watteau's successors never entirely lost their master's sense of light and colour. In a mild way Chardin attempted realism. Boucher, and later, Fragonard were influenced by that Japanese art which was to take such a prominent place in the movement of a hundred years later.' Elsewhere in his book Dewhurst shows that he is conscious of the reverence in which both Constable and Turner held Claude and Poussin and how the Impressionists, too, respected their experiments with light and perspective, albeit within a classical formulaic construct. Thus a convergence of influence can be traced between the two great English Romantic painters and the avant-garde French Impressionists of the late nineteenth century. It has to be said that none of the above, concerning the French antecedents for Impressionism, appeared in Dewhurst's *Studio* articles of 1903. So perhaps Pissarro's admonishment had had its effect!

However, he concludes this section in the book emphatically:

Ingres, a pupil of David, taught his students that draughtsmanship was more important than colour... Such teaching was bound to provoke dissent, and the germs of the coming revolution were to cross from England... British artists showed the way in the fight against tradition and form, which resulted in the School of Barbizon, and its great successor, the School of Impressionism.

By 1900 Impressionism had been struggling for recognition and legitimacy for 30 years, but it could be said that it came of age at the Paris International Exhibition of that year, where it met with general acceptance and approval, at least by the

French public. The dawn of a new century triggered a number of histories surveying the art of the nineteenth century, which attempted to put into perspective the phenomenon of Impressionism: where it came from, how it developed and its impact on modern art. Dewhurst's book *Impressionist Painting, Its Genesis and Development* published in 1904 was by no means the first in a crowded field to explore the territory. His views were not new or original. The impulse that the British painters gave to the Romantic movement in French art is clearly documented and acknowledged by both contemporary and subsequent commentators. But it is perhaps the categorical and jingoistic nature of Dewhurst's writing which concerned some people, along with his insistence that the Impressionists merely developed techniques which had been anticipated in the work of Constable, Turner and Bonington.

Dewhurst admits that he collected material from a wide range of sources for his articles on Impressionism, which were later amalgamated into his book, but he makes no specific acknowledgements and it is clear that he cherry-picked opinions to support his thesis. In 1891, the highly respected critic P.G. Hamerton writing in *The Portfolio* on 'The Present State of the Fine Arts in France', said:

> The first thing to be said about Impressionism, is that it need not be considered a novelty, especially by Englishmen. Turner is looked upon as a precursor, the most practical difference between his later and fully emancipated work and that of the modern French Impressionists being that Turner painted in the studio whilst these men work almost exclusively in the open air.[23]

Hamerton goes on to say that 'Constable, in his sketches, was decidedly an Impressionist'. It was in 1891 that Dewhurst left Manchester for Paris to study in the art schools, and there can be little doubt that Hamerton's article would have been among 'the mass of material' on the subject of Impressionism that he was accumulating. Earlier in 1888, in the *Magazine of Art*, George Clausen, later to become professor of painting at the Royal Academy, had written, when defending art students who went to Paris for their training:

> We never tire of pointing out, with pardonable pride, that the parent influence of the modern French naturalistic school was that of our own John Constable ... Constable's direct influence here was practically nil, but in France it was immediate and far reaching in its results; and he stands as one of the founders of a school, which ... is the strongest force in art at this present time. And now that we in turn receive back an impulse from France ... behold the ancients arise, and solemnly warn us that we are going astray![24]

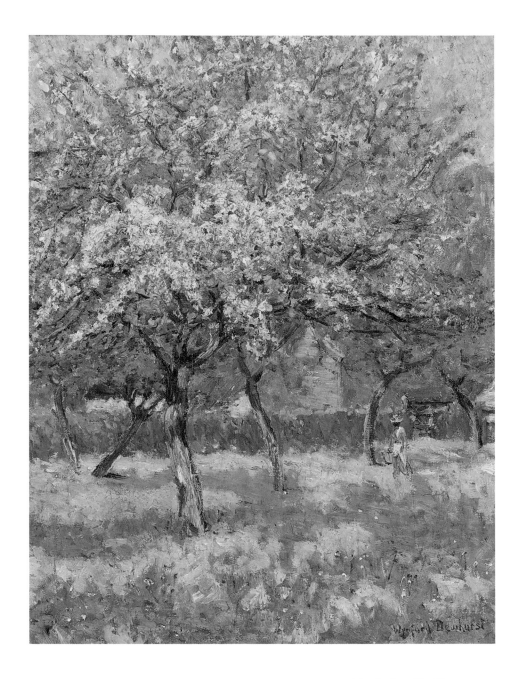

An Orchard in Bloom
c 1908, oil on canvas
46.3 x 36.2cm

Private collection © Christies Images/
Bridgeman Images

Le Déjeuner dans Le Jardin
c 1903, oil on canvas
81 x 62cm

Private collection

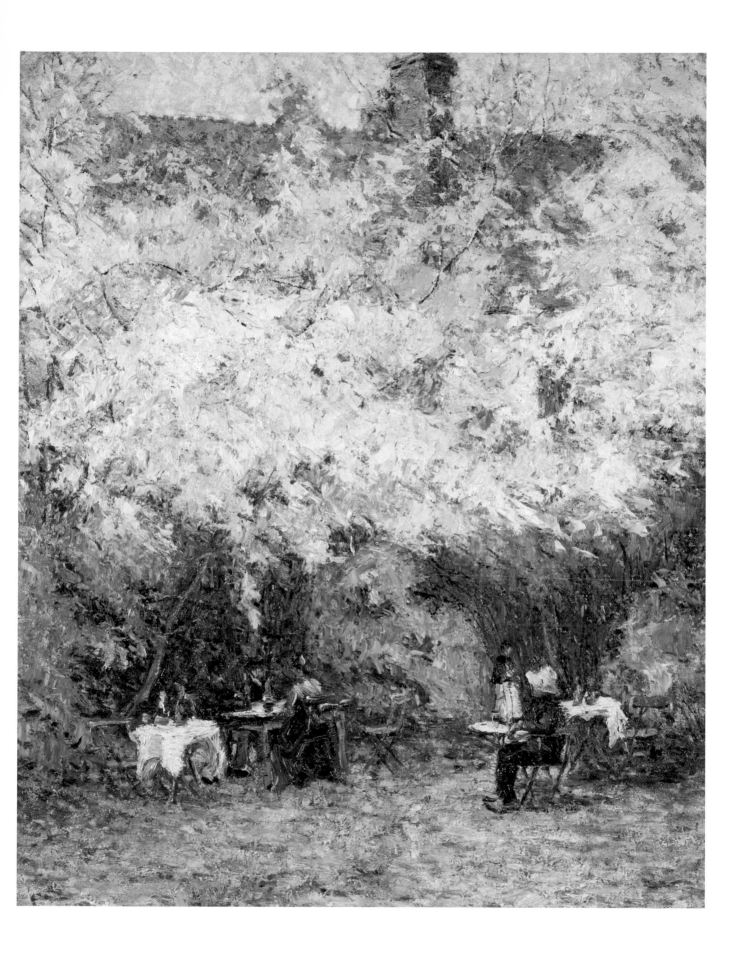

Le Moulin Brigand, Crozant
c 1908, oil on canvas
79 x 100cm

Private collection

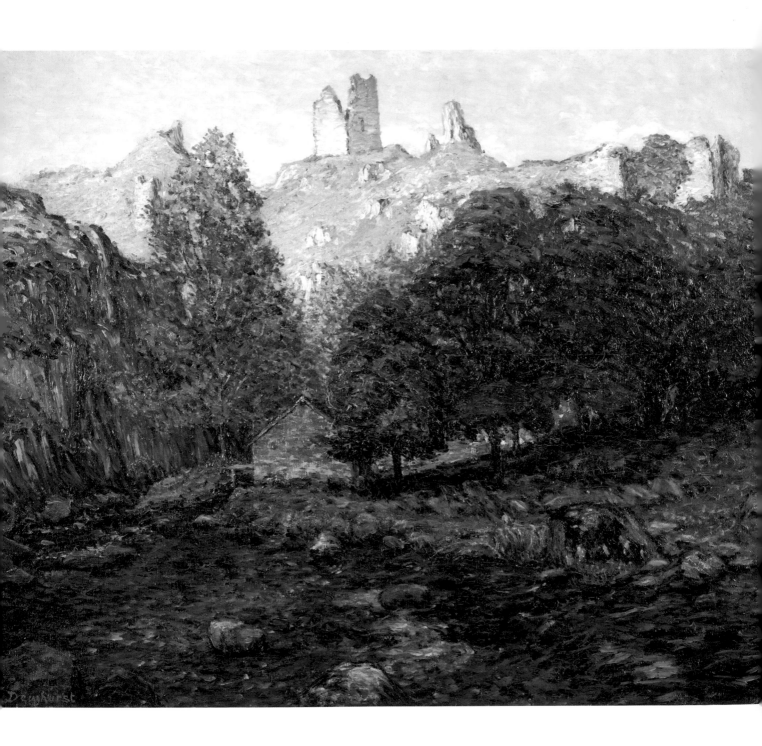

These are sentiments that seem to find clear echoes in Dewhurst's more emphatic statements fifteen years later. So perhaps the seed for his 1904 book had already germinated by the time he went to Paris?

Of all the books that came out around the turn of the century chronicling the development of Impressionism, the French side of the debate was probably best put in Camille Mauclair's *The French Impressionists 1870-1900*, first published in French in 1900, and translated into English in 1903, a year before Dewhurst's book appeared. Dewhurst seems to have had some respect for Mauclair, a Parisian novelist, poet and art critic, whom he quotes at length in the appendix to his book, largely on the scientific explanation of Impressionism and colour theory. However, the underlying narrative put forward by each man was diametrically opposed. While Dewhurst laid stress on the English antecedents of Impressionism, Mauclair clearly states, 'In Impressionism we have painting of a sort which could only have been conceived in France.' He goes on to say:

> the Impressionist movement is based upon the old French masters ... [the] movement is therefore entirely French, and surely if it deserves reproach, the one least deserved is that levelled upon it by the official painters [the art establishment]: disobedience to the national spirit.[25]

Both men are playing the nationalist card. Dewhurst wants to bolster support in Britain for the new school by claiming English roots, while Mauclair, although acknowledging the influence of Turner and the English romantics, feels impelled to say that the movement had its genesis in France, and implies it would have happened anyway with, or without, the help of the English painters. However, as with Pissarro, there is some ambiguity in Mauclair's stance, as at one point in his book, having established that the Impressionists regarded Claude Lorrain as one of their precursors 'from the point of view of decorative landscape arrangement, and particularly of the predominance of light in which all objects are bathed', he goes on:

> It is known that Turner worshipped Claude for the very same reasons. The Impressionists in their turn, consider Turner as one of their masters; they have the greatest admiration for this mighty genius, this sumptuous visionary. They have it equally for Bonington, whose technique was inspired by the same observations as their own.[26]

No such conciliatory message came from Dewhurst, who throughout his writings and speeches kept repeating his mantra that, 'It cannot be too clearly understood that the Impressionistic idea is of English birth.'

It has to be said that in the first two decades of the twentieth century the views

Claude Monet (1840-1926)
The Petite Creuse River
1889, oil on canvas
65.9 x 93.1cm

The Art Institute Chicago/Potter Palmer
Collection/Bridgeman Images

The Blue Valley
1908, oil on canvas
81.3 x 100.3cm

Manchester City Galleries

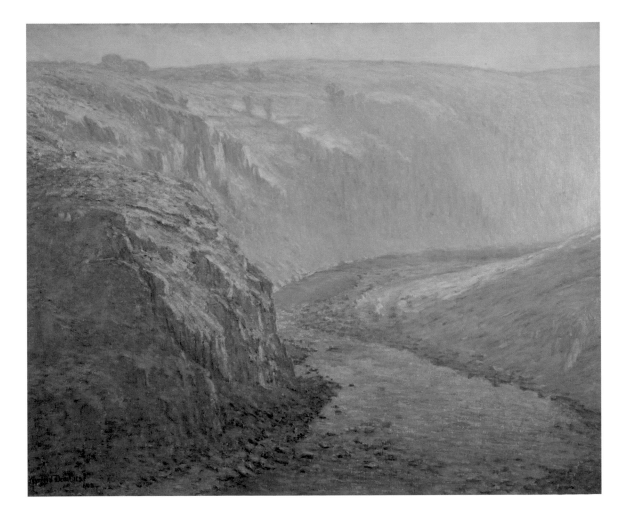

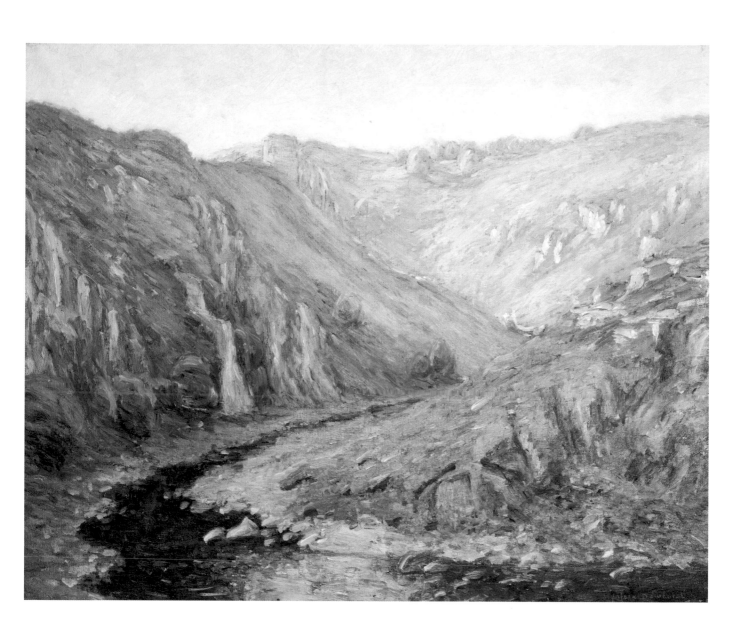

Valley of La Creuse
c 1910, oil on canvas
59 x 72cm

Private collection

A Country Walk
c 1910, oil on canvas
51.5 x 71cm

Private collection

Claude Monet (1840-1926)
The Geese
1874, oil on canvas
73.7 x 60cm

Sterling and Francine Clark Art
Institute, USA/Bridgeman Images

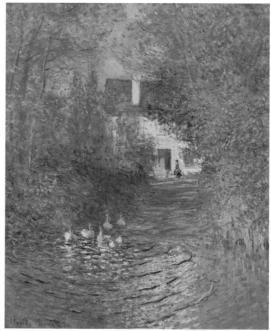

Moving the Geese
c 1908, oil on canvas
69 x 58cm

Private collection

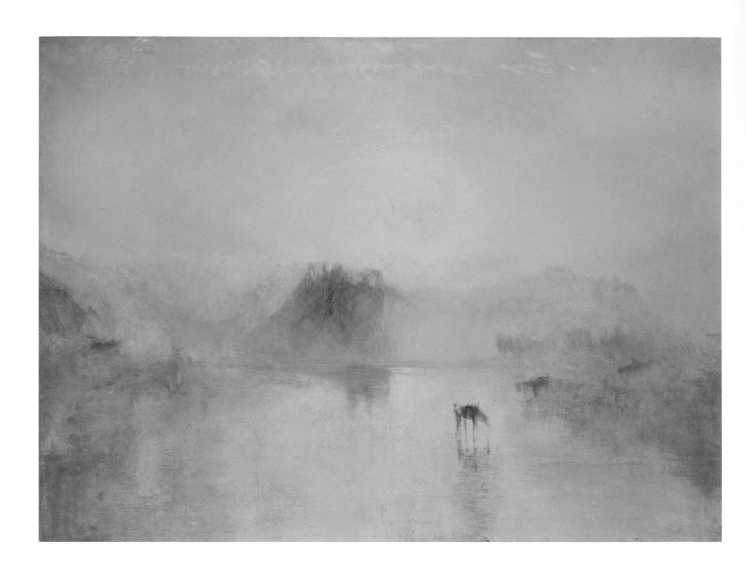

Joseph Mallord William Turner
(1775-1851)
Norham Castle, Sunrise
c 1845, oil on canvas
90.8 x 121.9 cm

Joseph Mallord William Turner
(1775-1851)
**Snow Storm - Steam-Boat off a
Harbour's Mouth** 1842,
oil on canvas
91.4 x 121.9cm

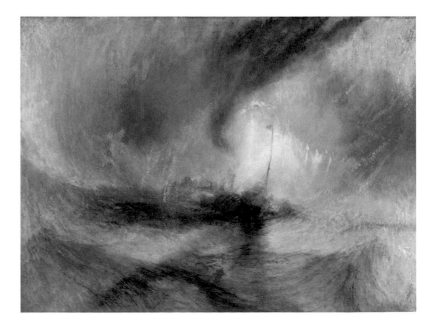

espoused and promoted by Dewhurst became the received wisdom adopted by most writers on both sides of the English Channel, albeit in a moderated form, without his excessive chauvinism. Most agreed how, in the 1820s, Bonington, and particularly Constable, with his showing of *The Hay Wain* at the Paris Salon of 1824, played a pivotal role in changing the direction of French landscape painting. They provided an impulse to the development of the Barbizon School, who in turn, with their *plein air* practices and natural motifs, were an inspiration to the Impressionists. Although the role of Turner in the ultimate emergence of the Impressionists was always more problematic, this began to change. John House, in the catalogue to the 2004 exhibition 'Turner Whistler Monet', has said:

> It was in the early 1890s that writers on art began regularly to invoke Turner's name in discussing the genesis of Impressionism. The critic Gustave Geffroy, a close friend of Monet, noted in 1891 that Monet and Pissarro had returned from their trip to London 'with the dazzling experience of the great Turner in their eyes.' And in 1892 Georges Lecomte, in the first book to be published on Impressionism, noted that Monet and Pissarro had 'found the definitive confirmation of their researches' in Turner's art when they saw it on their first visit to London. Geffroy elaborated on the impact of Turner in his book on Impressionism published in 1894 ... he noted that Monet and Pissarro had found, on seeing his work 1870-1, 'the joy of perceiving that what they were seeking had already haunted another spirit'. [27]

So Dewhurst's conclusions were by no means exclusively his own. On the English side of the Channel writers were reaching the same consensus. Sir Walter Armstrong, in an important critical reassessment of Turner's work in 1902, wrote, 'Between *Rain, Steam and Speed* and a good Monet I can see but few essential differences. In short the Englishman allowed his invention to work as he painted, while the Frenchman strenuously confines the whole business to nature, eye and hand. So that in one case we get an organised, in the other, a selected impression.'[28] In the same year, in his book *Nineteenth Century Art*, D.S. MacColl, an early apologist for the Impressionists, promotes Turner's proto-Impressionist image by saying that his art gave Monet and Pissarro 'the impulse and the clue to the rendering of high and vivid illumination'.[29] In 1910, C.L. Hind in *Turner's Golden Visions*, speaks of *Rain, Steam and Speed* as 'that masterpiece of Impressionism' and suggests it is testament to Turner's modernist credentials.[30]

Later in the twentieth century there were voices raised against this Turnermania and the adoption of him as a harbinger of modern art. The influential critic Roger Fry, who organised the seminal exhibition 'Manet and Post-Impressionism' in London in 1910, was one of the first. He wrote in 1931, 'Turner was a man of glittering genius

but with an imagination that could not express itself within the limits of the painter's medium ... It was not, strictly speaking, a painter's sensibility that prompted him. It was the love of whatever was scenically impressive or dramatically striking that fired his imagination.'[31]

To Fry, John Constable was the 'purest, most original, and most painter-like of all English artists, almost the only one who created a new vision ... the only one to spread his influence beyond the limits of his native country'. And in language which again finds echoes from Dewhurst's writings he says that, after declining into a state of 'trivial ineptitude' in the nineteenth century, British landscape painting experienced 'the reflux of Constable's impulse ... returned to us, belated and already rather exhausted, from France'.[32]

Fry's rather dismissive view of Turner's legacy gained some traction. In 1932 John Rothenstein, later to become director of the Tate Gallery, wrote of Turner that, 'A comparison between his studies and his completed pictures shows how freely and how constantly he replaced what he saw by what he imagined.' Rothenstein concludes that 'Turner was a solitary titan' and goes on to say:

> Artists of a later day have rightly recognised in him their predecessor in 'the rendering of form in movement and the fugitive phenomena of light'; yet they themselves have derived little directly from him. The interest of the impressionists in such things was largely objective, for their rendering of light in close conformity with the facts of vision, was, in effect, the culmination of European artists' age-long recurrent struggle to render nature accurately. But in this struggle Turner played no part... Light was to him the medium in which his inner vision could be best rendered; he desired to create light rather than to reflect it.[33]

But the naysayers found themselves in the minority and rowing against the tide. In his masterly review of Turner's fluctuating legacy, *J.M.W. Turner: The Making of a Modern Artist*, Sam Smiles has stated:

> Fry's antipathy to the more enthusiastic claims for Turner's genius, and especially his presumed connection with Impressionism, stands out because it was an increasingly unfashionable position to adopt. By the mid-1930s Turner's anticipation of modern art was bedding down as one of life's more comfortable clichés. Formalist readings of his art meant that Turner's Impressionist credentials were now part of the accepted understanding of his achievement.[34]

The record speaks for itself. Why would Pissarro have said in 1892, 'It seems to me we are all descended from the English Turner... There is much for us to learn in the English School'? Why would Monet have repeatedly returned to view the Turners at

the National Gallery on his visits to London? And why would both Monet and Pissarro put their signatures, along with seven other Impressionist painters, to a letter in 1882 to Sir Coutts Lindsay of the Grosvenor Gallery, saying that they were a group of French artists 'united by the same aesthetic tendencies against convention and ... applying themselves with passion to the rendering of the reality of forms in movement, as well as to the fugitive phenomena of light, [who] cannot forget that it has been preceded in this path by a great master of the English School, the illustrious Turner'.[35]

No one is suggesting, not even Dewhurst himself, that after seeing the Turners in London in 1870-71, Monet and Pissarro might have returned to France painting with 'soapsuds and whitewash',[36] but, of course, Turner's work was intriguing, instructive

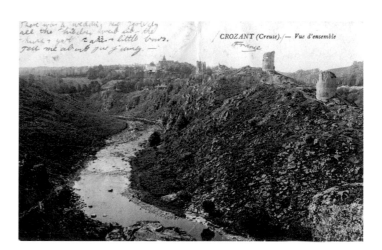

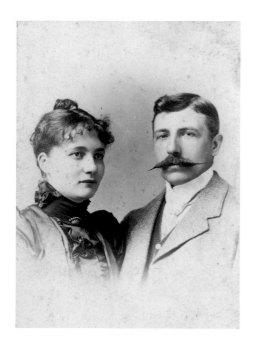

A Corner of the Garden
1905, oil on canvas
59.7 x 73cm

Private collection

Philip Wilson Steer
(1860-1942)
Summer at Cowes
1888, oil on canvas
50.9 x 61.2cm

Manchester City Galleries

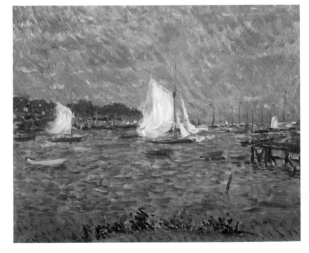

and influential to the young Impressionists at this formative stage in their artistic journeys. They were given confidence that they were heading in the right direction and that someone before them had attempted a similar route. As one writer in 1911 put it, 'Turner was the pioneer. It was he who established the theories set out in the Café Guerbois by men who had yet to see his work.'[37] But when they did see the work of Turner, during their enforced sojourn in London, the 'scales fell from their eyes'. Monet might have said in 1918, towards the end of his long life, 'at one time I greatly admired Turner; today I care less for him',[38] but this only offers indirect proof that, at an earlier stage, Turner's influence was significant. Like all great artists, Monet and his colleagues developed over time their own solutions, style and individuality. John House has put this succinctly, 'After Monet had first encountered his work, Turner was one of his reference points for the rest of his career. But Turner's presence in his work cannot be gauged simply by visual similarities: his paintings offered a challenge to which Monet had to make his own distinctive replies.'[39]

With the growth of internationalism in art at the beginning of the twentieth century and the emergence of truly cosmopolitan movements, such as Symbolism, Surrealism, Cubism, Futurism, etc., the concept of nationalism in art faded and became irrelevant. Dewhurst's flag-waving and propaganda began to look dated. Arguments as to where Impressionism was conceived, or who was the first Impressionist, or which nation can take credit for understanding it first, became immaterial and futile. In a lecture to the Art Workers' Guild in 1891, Philip Wilson Steer, perhaps the leading practitioner of Impressionism in England at the time, said:

> Impressionism has always existed from the time when Phidias sculptured the Parthenon frieze... Impressionism is of no country and of no period, it has been from the beginning; it bears the same relation to painting that poetry does to journalism. Two men paint the same model; one creates a poem, the other is satisfied with recording facts...[40]

Steer's pragmatism would certainly have not gone down well with Dewhurst, and nor would he have appreciated the following statement by George Moore: 'It may be doubted if it will ever be possible to discover who painted the first impressionist picture ... It certainly was not Constable or Turner.'[41]

In 1911, in an article in the *Contemporary Review* entitled 'What is Impressionism?', Dewhurst wrote; 'It may be said that we are all impressionists now.'[42] The article was his last on the subject of modern painting and can be seen as a codicil to his book. All the old arguments are rehearsed, but there is perhaps a more mellow, less bellicose tone than before. There is also one significant difference to his previous writings on the subject of Impressionism. He appears to have discovered an accomplice in the writings

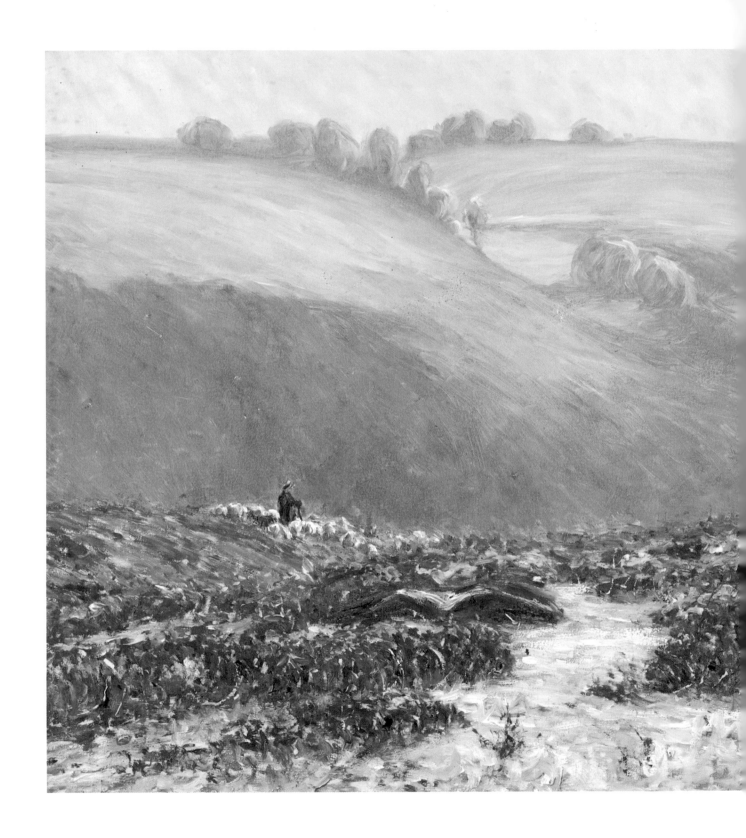

Autumn Morning, Heatherland
c 1913, oil on canvas
42 x 52cm

Private collection

Paul Dewhurst

of the late-departed, but still hugely influential art critic, John Ruskin. In Dewhurst's book, Ruskin had only merited two passing references. But now it was as if Dewhurst realised that he had overlooked the value of invoking the spirit of this powerful ally. His thoughts may have been focused by the fact that, since the publication of his book, the works of Ruskin had been painstakingly translated into French by Marcel Proust, following which there was a wave of enthusiasm for the teachings and tenets of the great man in Paris.

Then, remarkably, Dewhurst recalls a chance remark from Monet during an 'interview' in the Café Royal, London, in February 1900, when they were discussing the work of Turner. Monet turned to him and said, 'Have you ever studied Ruskin?' Dewhurst says he was 'startled' by the question, but the significance of it clearly did not impact on him sufficiently at the time for him to develop it further in his book. It lay dormant in his mind until Ruskin's writings and philosophy became the rage in France and he realised what a valuable recruit to his cause Ruskin would be. He excuses himself, in the 1911 article, for not 'linking up' in his mind the connection which might, or might not, exist between Ruskin's writings and Monet's paintings. He explains:

> for up [to] that time I had always regarded Ruskin as strongly antagonistic to Impressionism. Yet not so, for what do we find? Simply this, that ninety per cent of the theory of Impressionist painting is clearly and unmistakably embodied in one book alone of all Ruskin's voluminous output, namely, in his *Elements of Drawing*. [43]

Now fully convinced of the 'link', he goes on to say that the book, 'forms a magnificent compendium of the art of impressionist painting, and ought to be in the hands of every art student and connoisseur'. After three pages spent comparing the points made by Ruskin in *Elements of Drawing* with the practices of the Impressionist painters, he concludes with the excitement of a man who has found the last piece of a jigsaw:

> I am compelled to cease my analogies here, but the student who will trouble to dig into *The Elements of Drawing* will discover how, in the matter of composition, of touch, of tree drawing, and the rendering of sea and sky, Ruskin's theories form the very foundation of impressionist painting; and no better origin can be desired. [44]

In this 1911 article there is no hint that he is aware of the momentous events in the art world that were going on in Paris and the rest of Europe, but at the age of 47, after over ten years of fighting the Impressionists' corner and promoting their work, he seems content to rest his case and the piece seems to have an almost valedictory feel to it. He writes:

After superhuman efforts and with lapse of time they [the Impressionists] succeeded, and have actually transfigured not only the art of their own country but that of every nation wherein art obtains. The sun now penetrates where gloom held sway, its blessed rays bringing joy to the saddest of lives and surroundings.[45]

It was as if, having recruited John Ruskin to his cause, Dewhurst concluded that, as far as his long campaign to have the British origins of Impressionism recognised was concerned, it was now 'game, set and match'.

Notes

1 Letter from Camille Pissarro to his son Lucien dated 8 May 1903. See John Rewald (ed.), *Camille Pissarro: Letters to his son Lucien*, London, 1943, p. 355.

2 George Moore, *Confessions of a Young Man*, London, 1888, pp. 49–57.

3 Lorenz Eitner, *Géricault his Life and Work*, London, 1983, p. 218.

4 Francoise Cachin, *Paul Signac: From Delacroix to Neo-Impressionism*, Paris, 1978, pp. 69–70.

5 William Vaughan, *British Painting: The Golden Age from Hogarth to Turner*, London, 1999, p. 7.

6 Quoted in Anita Brookner, *The Genius of the Future: Essays in French Art Criticism*, New York, 1988, p. 53.

7 Patrick Noon (ed.), *Constable to Delacroix: British Art and the French Romantics*, London, 2003, p. 192 (Tate Britain Exhibition Catalogue).

8 Carl Peacock, *Richard Parkes Bonington*, New York, 1980, p. 96.

9 Harold Isherwood Kay, 'The Hay Wain', *Burlington Magazine*, Vol. 62, No. 363, June 1933, pp. 281–3.

10 Kenneth Clark, *Landscape into Art*, London, 1949, p. 80.

11 Patrick Noon, op. cit., p. 11.

12 Quoted in Wynford Dewhurst, *Impressionist Painting, Its Genesis and Development*, London, 1904, p. 31.

13 When Turner died he bequeathed to the nation many paintings, including *Dido building Carthage* and *Sun Rising Through Vapour*. These two paintings came with the condition that they should be displayed alongside Claude's *Landscape with the Marriage of Isaac and Rebecca* and *Seaport with the Embarkation of the Queen of Sheba*. By linking these paintings together Turner wanted to ensure that his association with Claude would endure beyond his lifetime.

14 See note 1.

15 Quoted in Wynford Dewhurst, op. cit., p. 61.

16 *The Artist*, 1 June 1892, Vol. 13, p.190. Quoted in Sam Smiles, *J.M.W. Turner: The Making of a Modern Artist*, Manchester, 2007, p. 95.

17 Luke Herrmann, 'The Pissarro Family and Turner', *British Art Journal*, September 2009, Vol. 10, Issue 2, p. 15.

18 John Gage, *J.M.W. Turner: 'A Wonderful Range Of Mind'*, Yale, 1987, p. 9.

19 Luke Herrmann, op. cit., p. 15.

20 Ibid., p. 15.

21 Quoted in Wynford Dewhurst, *Impressionist Painting: Its Genesis and Development*, London, 1904, p. 80.

22 Quoted in Wynford Dewhurst, *Impressionist Painting: Its Genesis and Development*, London, 1904, p. 61.

23 P.G. Hamerton, 'The Present State of the Fine Arts in France', *Portfolio*, February 1891, pp. 67–74.

24 George Clausen, 'The English School in Peril: A Reply', *Magazine of Art*, 1888, p. 223.

25 Camille Mauclair, *The French Impressionists (1860–1900)*, London, 1903, p. 17.

26 Ibid., p. 12.

27 John House, 'Tinted Steam: Turner and Impressionism', in *Turner Whistler Monet*, 2004, p. 45 (Tate Britain Exhibition Catalogue).

28 Sir Walter Armstrong, *Turner*, London, 1902, pp. 159-60.

29 D.S. MacColl, *Nineteenth Century Art*, Glasgow, 1902, pp. 2-5.

30 C. Lewis Hind, *Turner's Golden Visions*, London, 1910, pp. 214 and 279.

31 Roger Fry, 'Turner and Pissarro', *New Statesman and Nation*, 10 October 1931, p. 437.

32 Roger Fry, *Reflections on British Painting*, London, 1934, pp. 90 and 103.

33 John Rothenstein, *Nineteenth-Century Painting*, London, 1932, pp. 75 and 77.

34 Sam Smiles, *J.M.W. Turner: The Making of a Modern Artist*, Manchester, 2007, p. 113.

35 Letter quoted in Eric Shanes, *Impressionist London*, New York, 1994, p. 173.

36 This is a reference to the critical reaction to Turner's 1842 painting *Snow Storm - Steam-Boat off a Harbour's Mouth* which one critic called nothing but a mass of 'soapsuds and whitewash'. However, John Ruskin commented in 1843 that it was 'one of the very grandest statements of sea-motion, mist and light, that has ever been put on canvas'.

37 James Mason, *The Charm of Turner*, London, 1911, pp. 17-18.

38 Quoted in René Gimpel, *Diary of an Art Dealer*, London, 1966, p. 73.

39 John House, op. cit., p. 37.

40 Steer's address to the Art Workers' Guild is reprinted in D.S. MacColl, *Life, Work and Setting of Philip Wilson Steer*, London, 1945, pp. 177-8.

41 George Moore, *Reminiscences of the Impressionist Painters*, Dublin, 1906, p. 41.

42 Wynford Dewhurst, 'What is Impressionism', *Contemporary Review*, Vol. XCIX, 1911, p. 302.

43 Ibid., pp. 295-6.

44 Ibid., p. 301.

45 Ibid., p. 289.

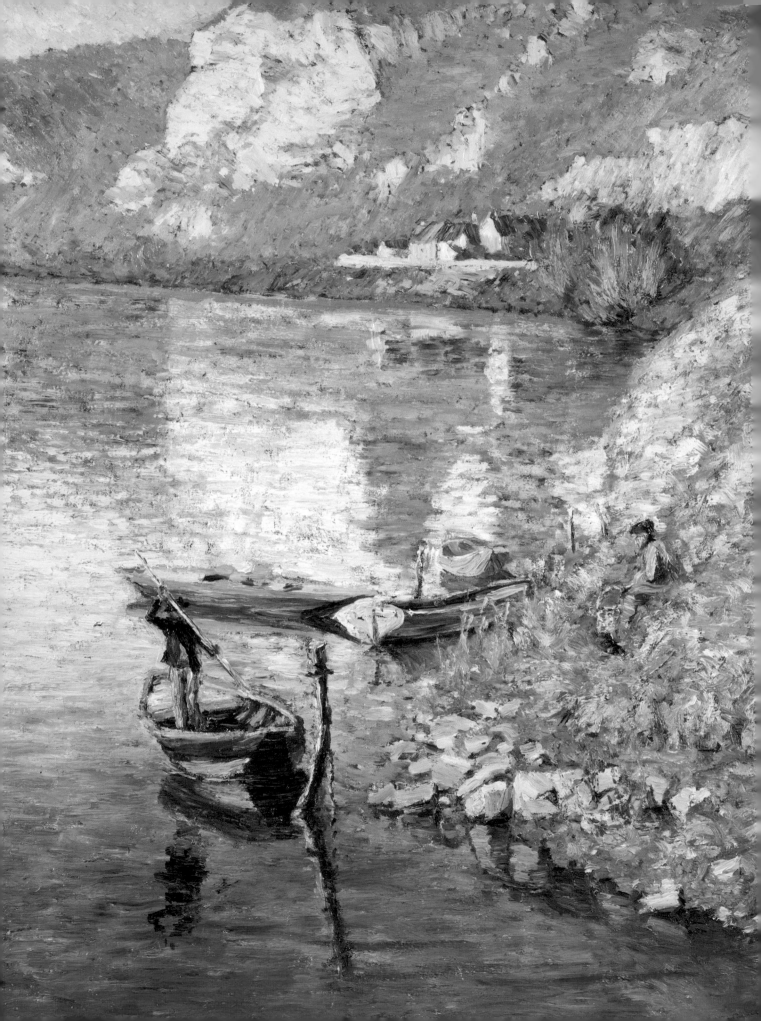

3. The Man and His Legacy

What's in a name?

I have endeavoured, by precept and by example, to preach the doctrine of Impressionism, particularly in England, where it is so little known and appreciated.

Wynford Dewhurst (1904)

Mr Wynford Dewhurst has made himself so impossible to disregard in any summing up of the art of our times. There is such a dominating personality in everything he does, such vehement individuality, that all students of art, whether they like his work or whether they do not, must inevitably accept it as having a special significance.

Alfred Lys Baldry (1914) [1]

Dewhurst's father
aged about 30

The Ferryman, Les Andelys
1903, oil on canvas
82 x 63cm

Private collection

W ynford Dewhurst was born Thomas William Smith on 26 January 1864. He was the first son to be born to James Robert Allen Smith and Ellen Dewhurst. At the time, the family was living in Newton Heath on the north-eastern industrial fringe of Manchester. It was an area of engineering works, cotton mills and row upon row of red-brick terraced houses. Thomas William Smith was the third of seven children, all but one of whom were born into this gloomy and grimy area in the hinterland of the great, and prosperous, city of Manchester.

James Robert Allen Smith was the epitome of the Victorian self-made man, who through diligence and hard work improved his family's status and fortunes, so that by the time young Thomas was six, they were living in the newly developed leafy suburb of Heaton Moor, to the south-east of Manchester, with two servants in the household. The census returns record James's steady climb through warehouseman, commercial clerk, cashier and manager, until in 1881 he is described as being the owner of land and houses and as being of independent means. He became a stalwart of his local community, making influential friends in the church, the Conservative Association and the Freemasons, and by 1883 he was an elected member of Heaton Norris Local Board (council). So, Thomas (later to become Wynford Dewhurst) had a comfortable start in life, and after benefiting from a private tutor at home was sent, at the cost of 40 guineas a year, to Mintholme College, a private school, near Preston. As the eldest son, his father clearly had high hopes for him and through his contacts arranged for him to be articled to a Manchester firm of solicitors. But the young man enjoyed sketching and painting in watercolour and began submitting his work to local magazines and journals with some success.

After a short spell at Manchester School of Art, Dewhurst, like so many aspiring young artists of the day, went to Paris to gain a training in the École des Beaux-Arts, where he was a pupil under the ultra-conservative painter, Jean-Léon Gérôme. Later he moved to the more progressive ateliers of the Académie Julian and Académie Colarossi. In 1906 he wrote an article in *The Grand Magazine*, saying that he went to Paris for 'a few years of good and necessary drilling at drawing pure and simple', and that he tolerated figure and portrait work, which was never particularly attractive to him, as a means to an end – to gain a knowledge of draughtsmanship. He went on to say:

> At an early age my predilections led me to choose landscape painting as the best means of expressing my pent-up aesthetic emotions. I loved the open air, the country-side life, and all it means. With equal intensity I abhorred city life and its concomitants. Hence my selection. I must also have been born with an irrepressible love for brilliant colours, and especially for reds. That boyish love for rich colour has endured and has certainly had its effect in the moulding of my style.[2]

In the same article Dewhurst explains that he abstained from painting in the Paris schools, and concentrated on drawing, because 'the palette selected and insisted upon by the school professors was enough to convince me that no benefit could accrue to me by its adoption'. Illustrating his increasing independence of spirit, he goes on, 'For such a dark and horrid mess I did not intend to sacrifice my own carefully chosen combination of colours, by comparison pure and radiant as a nosegay of spring flowers.' So at weekends he would travel into the countryside to the villages west of Paris, such as Cernay-la-Ville and Dampierre-en-Yvelines, where he could practise with his 'purified' palette, indulge his love of colours and paint *en plein air*, an important tenet for the would-be Impressionist. He also points out that the need to work speedily in such circumstances is another lesson not learnt by the studio artists. Some of these early student 'experiments', often painted on any material to hand such as chocolate-box tops, still survive and it is possible to follow his metamorphosis into a fully-fledged Impressionist painter. Clearly, Dewhurst had a well-thought-out, calculated and disciplined approach to his training in Paris. He manipulated it to serve his own ends, so that when he eventually finished his training in the schools he immediately started painting in a mature Impressionist manner. One has to remember that he was at this point 30 years of age, so older than the average graduate, and his *French Landscape* of 1895, painted in the Seine Valley, is remarkable in that it shows he has embraced the Impressionist principle of representing the visual world by the optical mixing of small dabs of colour, and that he has already adopted a colour palette befitting a follower of Monet.

At the start of his final year of training in Paris, Thomas William Smith changed

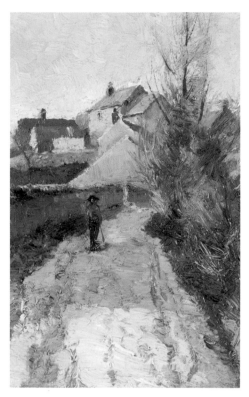

Village Scene
1894, oil on card
23 x 15cm

[inscribed verso Cerny, April '94]
Private collection

Man in Village Lane
1894, oil on board
23 x 15.2cm

[inscribed verso Yvette near Dampière,
May 1894]
Private collection

his name by deed poll to Wynford Dewhurst. It is possible that he had already been using the name as a pseudonym for his artistic work. Dewhurst never explained the change of name and left only a brief note in papers with his will saying: 'Assumed name Dewhurst (being mother's maiden name) at outset of artistic career, 1894.' The change of name was clearly an exercise in what we would call today 'rebranding', or as the *Manchester Courier*, in a report of an exhibition of his work at the Knoedler Gallery in London in 1905, explained:

> Mr Dewhurst, who follows not unworthily in the footsteps of Claude Monet, is the son of the late Mr Allen Smith, of Heaton Moor. In the world of art there are many Smiths, and the young Manchester painter when he commenced his career wisely adopted a professional name...[3]

We have very few accounts of Dewhurst's appearance and personality. The extant photographs show a very smart, immaculately dressed man, with a penetrating stare and an upright bearing, who could at first glance be mistaken for a military man rather than an artist. One of the best accounts of his appearance and manner is found in an article in *The Crown, The Court and County Families Newspaper* of 1907:

Tall, broad-shouldered, black-haired, and florid in complexion, with a hearty debonnaire manner - always held in check by gentlemanly instinct - we have a worthy leader of a cult and a doughty champion of a cause. Lancashire grit he got from his father - from his mother Northern pertinacity.[4]

Although, after leaving for Paris in 1891, he never returned to live in Manchester, he was proud of his associations with the city and when he became an established artist he did return often to lecture at the City Art Gallery and to exhibit his pictures, and he took an interest in local causes such as campaigns for a new hospital and art gallery.

In a series in the *The Grand Magazine* of 1906, distinguished artists were invited to write a short paragraph on 'The Secret of Success'. Here we have perhaps the most personal and revealing statement of Dewhurst's beliefs and principles. As a self-portrait in words it is worth quoting in full:

> Success is to be obtained by love and desire. Specialise in some one branch of art. Concentrate your energy. Experiment and know what you want, then go for it single-mindedly. Hammer the same nail on the head all the time. Miss no chances; make them. You will mull many - no matter. He who makes no mistakes makes nothing!

> Work conscientiously, sympathetically, courageously. Develop your own aesthetic soul - don't vegetate in the shadow of the other fellow's. Have ideas and the grit to exploit them. Let the world know that you have arrived. Cultivate the business faculty, if haply you have any. It is that, allied with talent and personal magnetism, which commands success the world over. Make as many friends and as few enemies as possible. The rising man soon learns that multitudes of hidden hands are jealously holding him back.

> If riches be your aim, hit the popular taste and be guided by it. Originality spells ruin; people mistrust it and long familiarity is necessary for its acceptance. It is the second generation which rides to fortune on the back of the broken pioneer. (Yet a man is a leader in spite of himself.)

> Observe the ten commandments - they are the essence of wordly wisdom ... and work.[5]

In spite of this last statement there is no evidence that Dewhurst was particularly pious, but he was certainly brought up in a devout Christian atmosphere at home. His father was deeply involved with the church, being a founding member and subscriber to St Paul's Church, Heaton Moor, which was opened in 1876 and where he later served as churchwarden. The foundation stone of the church had been laid 'with full masonic honours' under the patronage of Lord Egerton, a prominent freemason, and Dewhurst's father was later to become an active member of a newly formed Lodge in

this burgeoning suburb. Although it seems that Wynford Dewhurst himself did not become a member of the fraternity, it can be seen that the young Thomas William Smith, aka Wynford Dewhurst, was brought up in a household with high moral standards and a sense of service to the community.

From his remarks on 'The Secret of Success', Dewhurst comes across as rather serious and humourless. In the quote at the head of this chapter the critic and painter A.L. Baldry refers to a 'dominating personality' and a 'vehement individuality'. He was certainly very sure of himself and his own opinions and did not suffer dissenters gladly or generously. He had gone to Paris to study at the age of 27 and one gains the impression he was rather aloof and disdainful of the usual student way of life. A lecture he gave to the Manchester School of Art in 1908 is very revealing about his reaction to his own Parisian training and his unusually business-like and dedicated approach to his artistic career. The *Manchester Courier* reported that he began by talking about the 'two vivid word pictures of the art student life in Paris that had been given to the world'. The first was *La Vie de Bohème* by Henri Murger, and the second the novel *Trilby* by George du Maurier published in 1894. He goes on to say that these over-dramatized and romanticised versions of student life were far removed from reality, and he has a sober warning for 'the young Britisher about twenty years of age, who arrives in Paris for the first time', whom he counsels to avoid the:

> pitfalls of shameful and ridiculous escapades which sap and hamper one's energies.
> One is much more of an artist or poet when clean in mind, body and attire, living and
> sleeping the regulation number of hours. The wearing of one's summer wardrobe
> in winter is no proof of talent, and a man can be a veritable genius on dry feet and
> three good meals a day. Long hair, big hat, greasy garments and dirty morals count for
> nothing at all where art is concerned.[6]

The newspaper does not report on how this advice was received by the Manchester art students! In spite of these dire warnings to the 'young Britisher' about to go to Paris, in the course of the same lecture Dewhurst expresses his admiration for the French art training on offer there. He declares that, 'in all these classes one received the best, most patient, yet most exacting tuition possible, from men of high culture and position, immaculately attired in frock coat and silk hat of fashion and wearing in their button holes the little insignia of decorations conferred on them by the Government'. This role-model was one to which Dewhurst clearly aspired and was reflected in his life-long attention to his dress and appearance.

Dewhurst's interest in politics and community affairs undoubtedly stems from the example of his father, who was active in public life and served on his local council for 25 years. On his return from France with his growing family, he rented a substantial

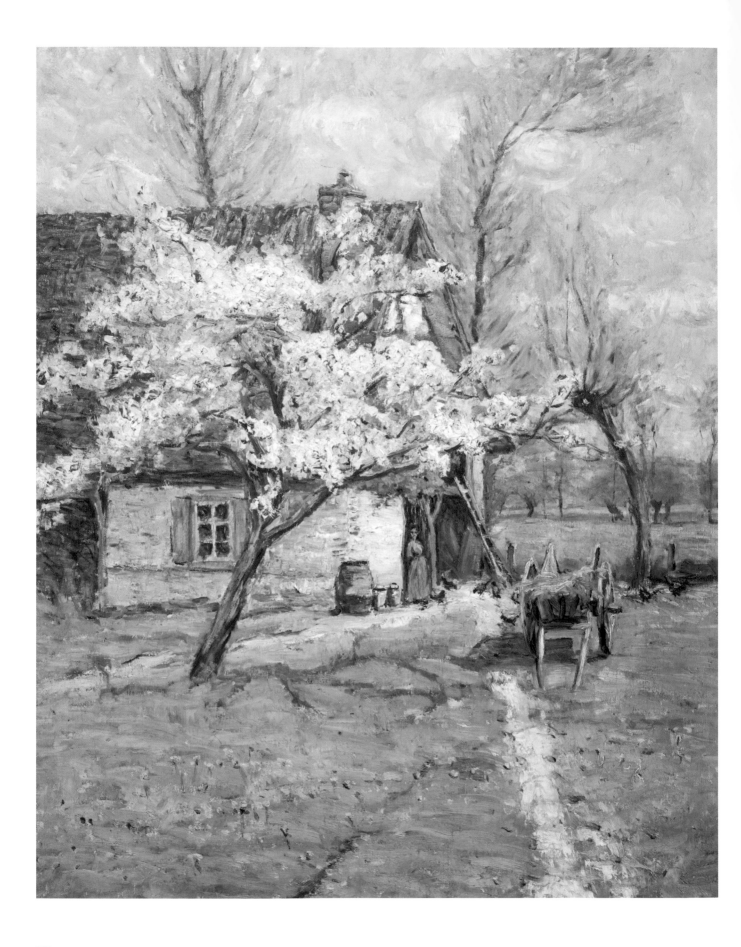

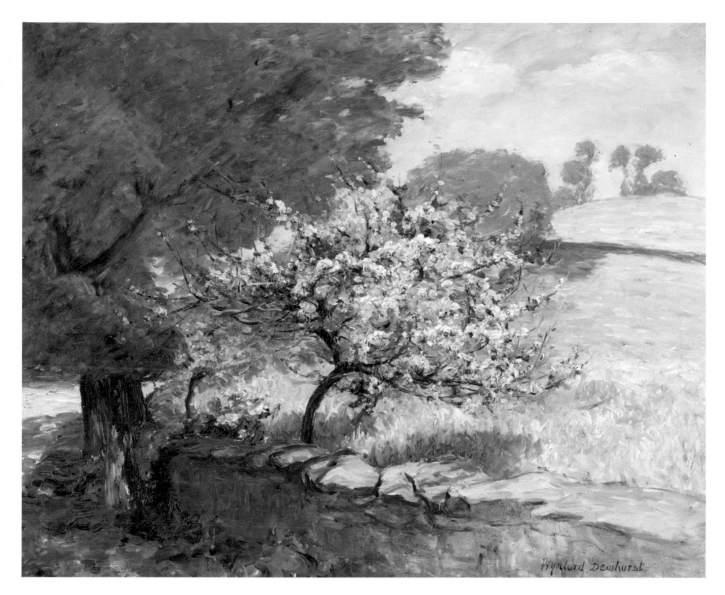

Blossom Overhanging Wall
c 1914, oil on canvas
64 x 79cm

Private collection

**Blossoms and Wild Flowers
at the Head of a Valley**
c 1914, oil on panel
79 x 51cm

Private collection

At the Cottage Door
c 1902, oil on canvas
92 x 71cm

Private collection

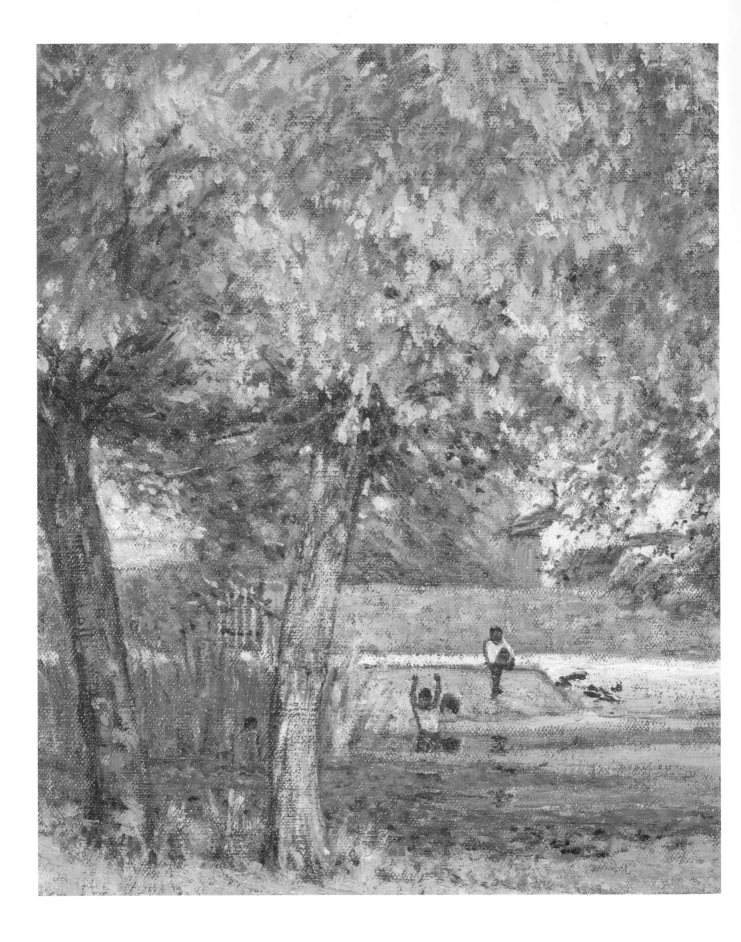

house at Chelmscote on the Buckinghamshire/Bedfordshire border. In 1907 he was elected to Buckinghamshire County Council and served on the Education Committee, but he does not appear to have made any significant contribution to proceedings as he spent so much of his time in France. It was, and still is, unusual for an artist to be so involved in politics and local affairs and it emphasises his determined individuality and how he was very much his own man. The *Manchester Courier* noted at the time of his election:

> In England the artist rarely takes a prominent part in public affairs, and Mr Wynford Dewhurst, who has just been elected a member of Bucks County Council, is possibly the only painter entitled to a seat in one of these local parliaments ... Mr Dewhurst is strong on the point of retrenchment and a determined opponent to all forms of extravagance.[7]

In 1910, on moving to Tunbridge Wells, he resigned from the council and presented to it the oil painting, *Heath Pond, Leighton Buzzard*, which had been painted some years previously. In his newly adopted town he continued to be involved in local matters, campaigning vigorously for a new art gallery and at the outbreak of the war in 1914 he was one of the first to volunteer as a special constable. His local newspaper reported in October that year:

> Mr Fred. W.V.B. Dewhurst, eldest son of Mr Wynford Dewhurst, of Grove Hill, Tunbridge Wells, has been gazetted permanent Second Lieutenant in the Royal Marines, and joins his regiment on Saturday ... Mr Wynford Dewhurst was himself one of the first Special Constables enrolled and has volunteered for service abroad as an interpreter. His daughter, Miss Dewhurst, is also training for work as a Red Cross Nurse, so that the family record is a very patriotic one.[8]

Dewhurst's love of all things French, and the French people, seems to have flourished rapidly from the very first moment that he arrived in Paris in 1891 for his training. In a letter from Paris to the *Manchester City News* in 1900, deploring the fact that that there were so few British visitors to the International Exhibition, held in Paris that summer, he tries to reassure his countrymen over the reception they will receive:

> It has been my lot to pass the greater portion of the last ten years in France ... and I can safely affirm that neither by look, word, or deed (excepting one amusing incident) have I had reason to feel that my presence was anything but welcome and agreeable to the good people around me. The inborn courtesy, good taste, and gaiety of the French is proverbial. I, together with hundreds of other Englishmen, have every reason to be grateful to France for educational facilities, for friendships, for numerous aesthetic treats, and not the least for advantages of travel and residence in this most picturesque and most paintable country in the world.[9]

**Heath Pond,
Leighton Buzzard** (detail)
c 1899, oil on canvas
60 x 79cm

Buckinghamshire County Council

In 1904 Dewhurst was co-opted on to a committee in Paris to promote the celebration of the Entente Cordiale which had been signed between the two countries in April that year. He organised a visit by 350 British working men, who were met by the president of the republic and the British Ambassador, attended the Opera and the Comédie-Française and were generally fêted by the authorities in Paris. The *Leighton Buzzard Observer* reporting on the event, said that:

> In the evening of Thursday on the St. Lazare Station there was a fine scene. A special train and the platform were crowded when Mr Dewhurst was called upon for a speech, which he gave standing on the steps of the train and immediately under a large French flag. As the train moved off cheers were given for Mr Dewhurst.[10]

Clearly, Dewhurst's involvement in public affairs and politics extended across the Channel. He counted among his friends the French ambassador in London, Pierre Paul Cambon, a very senior diplomat, and it may have been that it was through this contact that in 1908 he was awarded the insignia of Officier d'Académie of the Ordre des Palmes Académiques. This French order of chivalry, introduced by Napoleon in 1808, was intended for distinguished academics and figures in the world of culture and education. In 1866, the scope of the award was widened to include major contributions to French national education and culture made by anyone, including foreigners. Four years later, in 1912, he was awarded an upgrade to Officier de l'Instruction Publique. Obviously, Dewhurst was highly regarded among his French associates for his work towards maintaining and improving Anglo-French relationships. It would be nice to think that these awards were also, in part, recognition for the vigorous battle he fought in England on behalf of the French Impressionists and the contribution his book made to eventually gaining acceptance for this beleaguered group. Dewhurst was extremely proud of these two decorations from the French government and henceforth always included them on exhibition labels, letters to the press and official documents.

As a confirmed Francophile, spending several months of each year working in France, Dewhurst was particularly impressed by the amount of government support given to the arts in that country. He began campaigning in Britain for a Ministry of Fine Arts to promote, protect and fund the arts and to bring all cultural matters under the patronage of a government department. Dewhurst became a prime mover in a campaign to achieve this goal. In a letter to the *Daily Mail* of 20 April 1911, congratulating the editor on a leader advocating a Ministry of Fine Arts, he said:

> This is a reform which I have for years past been doing my utmost to help bring about and its necessity has, so far, not been denied by a single one of the individuals (MPs and others) or corporate bodies whom I have approached.

Can anyone visiting Paris, for instance, and reflecting upon the manifold and splendid exemplifications of the benefits accruing from the existence of a Ministry of Fine Arts, doubt that our country would not also find it an advantage?[11]

He goes on to say that the current state of affairs in Britain, 'renders us the object of daily ridicule to our more sensible, more progressive, and more imaginative neighbours'. As if to emphasise his argument, his letter is sent from Paris and he signs himself Wynford Dewhurst, 'Officier d' Académie'. In 1913 he wrote a series of very comprehensive articles in the *Art Chronicle* explaining what a Minister for the Arts would be responsible for and how such a system worked, with great benefits to all, in France. These articles were later reprinted as a booklet entitled, *Wanted: A Ministry of Fine Arts*. At the beginning of 1914 the idea was gaining momentum and a grand committee had been formed, including academicians (both painters and sculptors), architects, landowners and patrons of the arts, to put pressure on parliament to consider the proposal. The *Manchester Courier* reported that:

Manchester has the distinction of being the birthplace of Mr Wynford Dewhurst from whose efforts a scheme for the formation of a Ministry of Art in England is largely due. This movement, which if it comes to fruition, may well have great influence on the artistic development of the nation, already claims the support of many of the most virile and progressive artists of the Royal Academy. This fact is the more interesting when it is remembered that Mr Dewhurst is a modernist of the most pronounced type. That artists who have established themselves under the influence of schools other than modern should openly espouse a movement thus introduced is welcome proof that the Royal Academy is not entirely the reactionary body many people suppose.[12]

The newspaper went on to seek the views of people prominent in the arts in Manchester regarding this proposal. Among those interviewed was Cllr Walter Butterworth, former chairman of the City Art Gallery, connoisseur, collector of 'modern' art and good friend of Dewhurst, who prefaced his comments by saying, 'He [Dewhurst] is a man of great energy, and has advocated the establishment of a Ministry of Fine Arts in England with great enthusiasm.' However, Butterworth had mixed feelings about the project. He could see the benefits in official recognition for the arts, but he had concern that the administering body might become 'a rigid bureaucracy, petrified, and out of touch with live issues'. But Mr Bateman, curator of the Whitworth Art Gallery, expressed his approval of the scheme, commenting that 'it will bring all branches of art into closer unity and, although at times there might be undue interference, art would certainly be in a stronger position to achieve its purpose'.

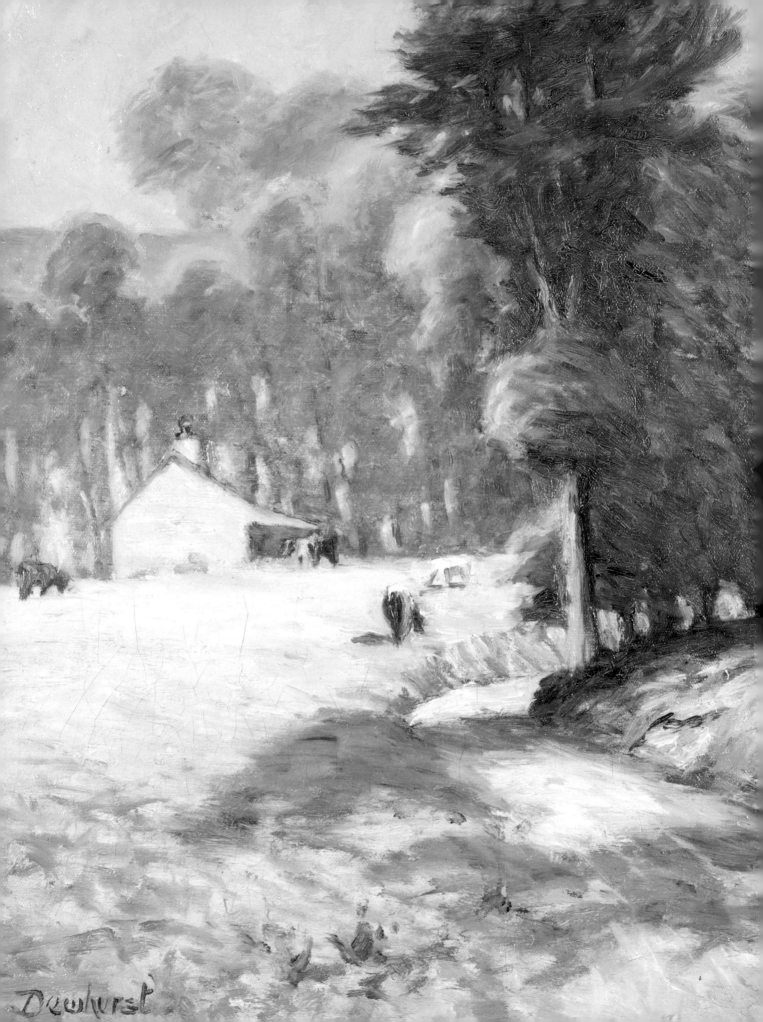

Dewhurst

Just how alert and astute Dewhurst was is evidenced by the fact that four days later the paper published a letter from him beneath the headline 'A Ministry of Art – No Opposition to the Proposal'. By way of introduction the editor writes, 'Below we publish, from Mr Wynford Dewhurst, a letter in reference to the proposed Ministry of Art, which was dealt with at length in the *Manchester Courier* last week. Mr Dewhurst was the originator of the movement in London, which promises to achieve success, and it will be seen that the tenor of his communication is distinctly optimistic. To see the State taking an adequate position in the realm of art has long been his keenest desire.' In his letter, Dewhurst, in 'bullish' mood declares that, 'the whole kingdom awaits with impatience the establishment of this nationally beneficial innovation – in fact, there is no opposition to the scheme from any quarter whatsoever, and the near future must assuredly see the establishment of a 'Ministry of Art' at Westminster'.[13]

Sadly, world events were to thwart this seemingly successful campaign on the brink of victory when in July 1914 war was declared with Germany. After the war the momentum had been lost, the socio-economic conditions were not favourable, and more pressing matters were on the political agenda. There was to be another world war before, eventually, in 1946, the Arts Council was formed to provide government funding for the arts, but it was not until 1964 that the first Minister for the Arts was finally appointed.[14]

With the onset of war in 1914, Dewhurst's artistic career lost its impetus and never really recovered. Exiled from his beloved France, his creative impulse seems to have waned. He did start exhibiting at the Royal Academy and between 1914 and 1926 had eight works accepted, but, with the exception of one, they were all paintings that had been completed before the war. His son Frederick wrote much later in a private letter to a friend, 'my father failed to find real inspiration in England. Hence the family made an annual trek to France'. For over ten years, up until the outbreak of war in 1914, Dewhurst had rented a house in the village of Crozant in the remote valley of La Creuse in central France and from April to October the family would live there. They became so integrated into the life of the community that family legend has it that Dewhurst was asked to become mayor of the village, but declined. Crozant was a centre for artists, many of whom settled in and around the Creuse Valley. Its popularity had been reinforced by the fact that in 1889 Monet spent several months there and it is here that he conceived his first true 'series'. In this remote, desolate part of France, he would take several canvases to the same site each day, replacing a canvas whenever he noticed the light had changed. It was this connection with Monet that first drew Dewhurst to the area and he set about emulating his 'Master' by painting tirelessly the same motifs at different hours and on different days. It was here too that he became friendly with Armand Guillaumin, who had exhibited

Upland Pastures, Normandy

c 1900, oil on canvas
45 x 33cm

['I have seldom seen sunshine better understood, or colour more fascinating than here.' *The Sketch* April 10 1901]

Private collection

at six of the eight original Impressionist exhibitions. He had settled in the valley in 1892 and also spent his days repeatedly painting the same motifs with a palette of progressively more vivid and violent colours. It has been said of his work that, 'some critics and historians saw in Guillaumin a precursor of Fauvism. This is certainly due to the audacity of that instinctive colourist who, from time to time, loved to put cobalt blue on oak trees and vermillion on the Creuse river.'[15] It is true that during his time working in close proximity to Guillaumin in the Creuse Valley Dewhurst's own palette became more vivid and luminous, taking on at times an almost Fauvist character.

 Deprived of his visits to France by the war, and having seen his highly successful campaign for a Ministry of Fine Arts frustrated when on the point of succeeding, he also had to cope with a personal disaster. He had invested heavily in Russian railway bonds, and after the revolutionary events of 1917 in Russia they became worthless. The family moved from the substantial house they were renting in Tunbridge Wells to a much smaller terraced property in Hampstead, north London. He did resume painting after the war but his work had lost its Impressionist passion and verve and he fell into a more conventional naturalism in the classic English landscape manner. He took to working more frequently in pastel and made several trips to Switzerland. In 1926 he had his last one-man show of 'Pastels of Chamonix and Elsewhere' at the Fine Art Society in London. After that he seems to have relied heavily on the patronage of a Cardiff businessman, Arthur Howell, who also ran the St George's Gallery in Hanover Square, London. It was at this time too that he began to produce, on commission, copies of his previous works. He did not really produce any significant work in the last twenty years of his life and the reputation of this once prolific and vibrant artist began to fade prematurely.

 With the battle for the acceptance of Impressionism behind him, and following the thwarting, at the eleventh hour, of his campaign to rally support for a Ministry of Fine Arts, Dewhurst seems to have been looking for other outlets for his organising and crusading talents. In March 1916 he decided to apply for the post of Director of the National Gallery of Ireland in Dublin. His application for this post reveals a great deal about the man, his character and opinion of his own capability and potential. Clearly he no longer saw himself simply as an artist and author but increasingly as one of the movers and shakers of the art world. In a letter to Cllr F. Todd, then Chairman of the Manchester City Art Gallery Committee, Dewhurst wrote:

> Attached to this letter is an advertisement from yesterday's *Times* which I ask you
> kindly to read. The duties of such a post would, I believe, suit me admirably so I have
> just sent in a formal application for it.
>
> If you will also please glance at the particulars of my career herewith, you will, I feel

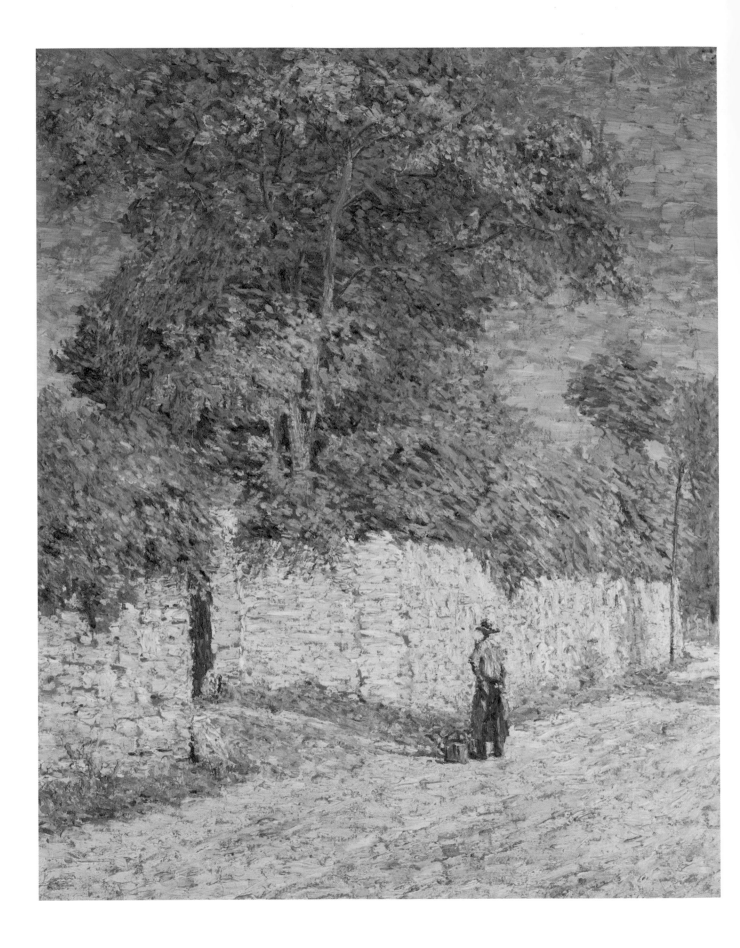

**A Figure Resting
on the Road at Giverny**
1896, oil on canvas
81 x 63cm

Private collection

sure, agree that in a great measure my whole life's training has suited me for such a post.

I have given three names as references as to my artistic and business abilities and standing generally and have taken the liberty of including you - which I trust will not be displeasing to you. The others are Lord Plymouth and Sir Charles Behrens.

I should greatly value your influence in this matter and will act upon any suggestions you may feel inclined to give me.

Thanking you in anticipation and with sincere regards.

Yours very truly

Wynford Dewhurst[16]

The post was awarded to an Oxford Renaissance scholar, but Dewhurst's choice of referees is interesting as there is not one artist, art historian or member of the art establishment among them. Lord Plymouth was chairman of the Union of Conservative Societies in England and had served as a government minister on two occasions. He had been chairman of the organising committee for the British Pavilion at the Venice Biennale in 1912 and 1914, when Dewhurst had exhibited, so perhaps the two men had met there, or it may have been through Dewhurst's campaign for a Ministry of Fine Arts. Sir Charles Behrens was a prominent Manchester politician and businessman who was Lord Mayor from 1909 to 1911. There is a sense that, in the world of Wynford Dewhurst, power and titles counted for more than cultural standing and artistic appreciation. It also raises the question as to how many close friends he had in the London artistic community. Perhaps his 'vehement individuality' and opinionated manner, coupled to the fact that he was in the habit of working abroad for a large part of the year, meant that he had no close confidants to call upon. In addition, his constant championing of modern French art and his crusade for a Ministry of Fine Arts, based on the model he saw as successful in France, will not have endeared him to some in the English art establishment. Perhaps, like Walter Sickert and James McNeill Whistler, he found that having a foot in both camps earned him as many enemies as it did friends. When he was proposed for the Royal Academy in 1920 by George Clausen, the naturalist painter, who empathised with the Impressionist aims, and Robert Colton, a sculptor and prolific producer of public memorials both in Britain and abroad, he failed to get enough support and after a period of time his candidature lapsed.

Dewhurst's exact relationship with Monet is also hard to divine. He certainly worshipped the ground on which Monet stood and dedicated his book to him, but there is no evidence that he was an intimate of the great man. In his book, he mentions, on two or three occasions, conversations with Monet but they are very much *en passant*,

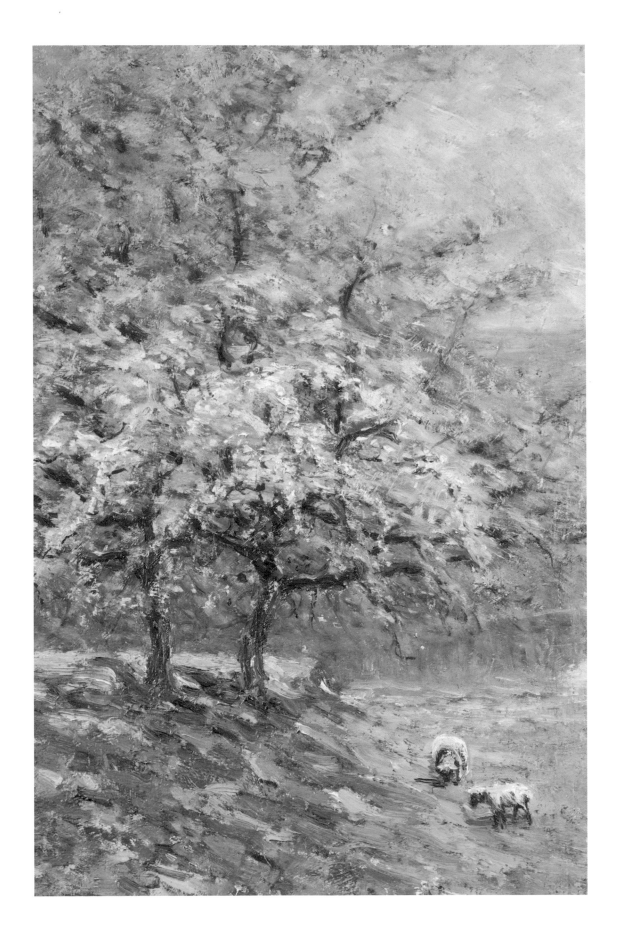

Claude Monet
(1840-1926)
Printemps à Giverny
1903, oil on canvas
89 x 93cm

Private collection/
Bridgeman Images

**Blossoms, Sunlight
and Sheep**
c 1914, oil on board
23 x 15cm

Private collection

View of Mont Blanc
1914, oil on panel
27.3 x 34.9cm

Private collection

Mont Blanc and Valley of Chamonix
1920, oil on canvas
64 x 79cm

[inscribed 'Grey Day Sept 1920' and with title verso]

Private collection

Valley of the Rhone
1914, oil on panel
26 x 33cm

Private collection

A Fountain at Versailles
c 1920-25, oil on canvas
81 x 101cm

Private collection

The Gardens at Versailles
c 1920-25, oil on canvas
63 x 79cm

Private collection

perhaps when visiting an exhibition, and there is no correspondence quoted, as there is with Pissarro, or accounts of visits to the house at Giverny. It is certain that if Dewhurst had been a frequent visitor he would have recorded such meetings. Many contemporary, and subsequent, writers refer to Dewhurst as a 'pupil' of Monet, but this was not the case. However, he was an admirer and desired to emulate the technique and also the spirit of the man whom he considered to be one of the world's greatest artists.

Twenty years after Dewhurst's death, his youngest son Claude (named after his father's hero) wrote, 'Newspapers such as the *Star, Standard* and *Daily Mail* all linked his work with Monet's and phrases like "most ardent disciple" and "finest pupil of Claude Monet" reached such a pitch as to alarm the older artist. He wrote personal and registered letters to Wynford Dewhurst stating, rather feebly, that the public might think that "pupil" meant paid pupil, and sought a disclaimer. Mr Dewhurst pointed out that it was the critics, not himself, that had allotted him that tribute.'[17] In 1905 Monet was again enraged, when Wynford Dewhurst put on a highly acclaimed showing of his own work in London's Knoedler Gallery, a short distance from the Grafton Gallery's exhibition of modern paintings, which featured Monet and other Impressionists. There is no other documentary evidence of this spat between the two men, but it seems that Dewhurst, although a devotee of Monet, was equally keen to be seen as his own man and was irritated by the implication in many reviews that he was merely a Monet 'imitator'. The Knoedler exhibition drew great attention to Dewhurst's art in direct comparison to the other Impressionists. The *Daily Mail* art critic wrote a review headlined, 'Notable Picture Exhibition. A Challenge to the French Impressionists', stating that 'Mr Dewhurst's little exhibition at Messers. Knoedler's Galleries on Bond Street, coming as it does at a time when all London is flocking to see the French Impressionists at the Grafton Galleries, must be considered much in the light of a challenge … It is gratifying to see that Mr Dewhurst can hold his own, even with Monet, whose palette and treatment he appears to have adopted.'[18]

Writing in the 1960s, Claude Dewhurst says of his father, 'He thought more, and did more, for the Impressionist movement as a whole than he did for himself.' Claude suggests that, in his opinion, the reason his father did not develop fully as an artist and had difficulty in establishing his own identity, was that, 'He devoted (some would say wasted) many years to lectures, articles and his book in England, trying to enlighten that country as to the newly emerging style; a style which he believed the English school to have originated.'[19]

Dewhurst's rise to success on the international scene had been rapid and quite soon his work was in demand for exhibitions all over the world. In 1897 he had his first landscape in oils accepted by the Paris Salon (Champs de Mars) and in the same

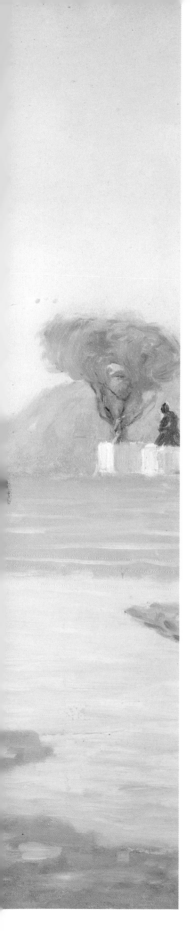

year also exhibited at the International Art Exhibition in Munich. From then until 1914 he was selected to exhibit at international exhibitions in Dresden, St Louis, Brussels, Paris, New Zealand, Buenos Aires, Rome and invited to submit works for the Franco-British exhibition in London (1908), the Japan-British Exhibition held in London (1910) and for the British Pavilion at the Venice Biennale of 1912 and 1914. In addition, he held one-man shows in Manchester, Liverpool, London, Paris, Wismar, Berlin, Dusseldorf, Cologne, and Hamburg. During these years Dewhurst was a truly international artist. His work was often singled out for exceptional praise, but invariably it was coupled with Monet's. In 1902 the distinguished art critic of the *Daily Mail*, P.G. Konody, reviewing the Summer Exhibition of the Royal Society of British Artists, wrote, 'Wynford Dewhurst, one of the younger members, who, accomplished artist as he was when we hailed his first appearance some few years back, now bids fair to rival and surpass the efforts of the school his art is based upon – the French and Belgium impressionists.' He goes on to say that Dewhurst's canvas *La Creuse, Sunrise* was 'the finest picture in the present RBA exhibition'.[20]

In addition to his prolific output as an artist, Dewhurst was writing and lecturing regularly on behalf of the Impressionist cause and in this field of activity he was equally successful. Editors were constantly asking him to write a piece on his chosen subject as they knew they would get an article that was frank, and sometimes controversial, but always accessible to the general reader. The *Leighton Buzzard Observer*, reviewing an article he wrote for *The Artist* on Monet, said:

> Mr Dewhurst's style is fresh and vigorous as a breeze from the sea; one almost regrets
> he is a painter, since as a writer he has the happy gift of attracting and interesting us.
> Impressionism in art is a subject about which many people of culture know little, and
> probably care less, but Mr. Dewhurst's clever and well-written article cannot fail to make an
> impression upon the reader.[21]

Dewhurst was conscious of the conflict that was developing between his writing and his painting. In a biographical article about Dewhurst in *The Ladies Field* in October 1904, the writer says that following the publication of his important and successful work on Impressionist painting, 'Mr Dewhurst proposes to bring to an end his career as a writer, and whatever reputation the future may bring him will be due [to] his brush and not his pen, for he is an artist to his fingertips.' Perversely, he did not give

The Terraces at Versailles
c 1920-25, oil on canvas
49 x 60cm

Private collection

up the writing, and as well as continuing to write about Impressionism, he took up other causes to promote, so that in the long run his very considerable literary talent did detract from his development as a painter. His art, beautiful and uplifting as it is, became repetitive and failed to provide any new insights into the artistic questions of his day. The 'English Monet' was a sobriquet he found difficult to shake off, being described by critics and reviewers variously as, 'the most brilliant exponent of the theories advanced by Claude Monet', 'a champion of the methods of Claude Monet', or put more patronisingly, 'It is easy to dismiss such frank homage as clever imitation, but the unusual technical skill demanded by the worship is of too high an order to be lightly treated.'[22]

In an introduction to the catalogue for Dewhurst's one-man show at the Durand-Ruel Gallery in Paris in 1911, the distinguished art critic of *Le Figaro*, Arsène Alexandre, after praising Dewhurst for defending in his own country 'with so much courage' the French Impressionist painters, goes on to say, 'He has appropriated the physical aspects of our impressionist painting so well that his nationality would be difficult for an uninformed viewer to guess ... It is rare to meet an Englishman with so little British accent in his artistic expression.' It is almost as if this celebrated member of the French art establishment was claiming Dewhurst as one of their own. It is true that a large part of Dewhurst's life had been lived in France since he first set foot on its soil *en route* for Paris in 1891 and he had enthusiastically accepted the French way of life. His work had received recognition in France before it did in England; he had been decorated by the French government;[23] three of his children had been born in France; he had absorbed French culture to the extent that he was equally at home on both sides of the Channel. Perhaps Arsène Alexandre was right – was Wynford Dewhurst really a French Impressionist? Could it be that like another of his Impressionist champions, Alfred Sisley, who was born of English parents in Paris, there was an ambiguity about his nationality and artistic loyalties?

In his 1906 article for *The Grand Magazine* Dewhurst is full of advice for the young artist on topics such as the best time of day to paint, 'spying out the land' and selecting the motif and the optimum size of canvases. But he also states, 'Experiment is the very breath and salt of art. Without it all progress is arrested and stagnation ensues.'[24] One cannot help feeling that in this respect he failed to follow his own advice. In 1906 he was still a rising star as an artist on both sides of the Channel, but then he seems to have been drawn away into causes that took up much of his time and energy. There can be no doubt that due to these activities his art suffered, as he failed to experiment and advance as an artist.

In the final analysis one has to conclude that, pleasing and technically proficient as Dewhurst's paintings are, it is his book and writings which sought to justify and

promote Impressionism, that represent his foremost legacy. He will be remembered for the crusade he fought, as one newspaper put it, with 'indomitable zeal' on behalf of Impressionism. It was his passionate and persistent lobbying through his writings and lectures that helped to ensure the eventual acceptance of Impressionism in Britain. But as an artist he was, and will be seen always, as a follower, a talented and sometimes brilliant devotee of Monet. It is as a writer that he was innovative, adventurous and eloquent. *Impressionist Painting, Its Genesis and Development*, the first book on Impressionism to be written in English, will always earn him a citation in the art history chronicles of the period. Although the book has sometimes been described by commentators as 'controversial' or 'misguided' because of its underlying thesis, Dewhurst's principal proposition – that English artists played a significant role in the development of French landscape painting in the nineteenth century – has now become the accepted orthodoxy on both sides of the Channel.

In the spring of 2016 an exhibition was held at the Musée Jacquemart-André in Paris entitled 'The Open-Air Studio: the Impressionists in Normandy'. The advance publicity stated:

> The 19th century saw the emergence of a new pictorial genre: open-air landscapes. This pictorial revolution, originating in England, would spread to the continent from the 1820s ... After the Napoleonic wars, English landscape artists (Turner, Bonington, Cotman ...) head for Normandy with their boxes of watercolours, while the French (Géricault, Delacroix, Isabey ...) make their way to London to discover the English school. Out of these exchanges a French landscape school was born... The goal of the exhibition is ... to highlight the critical role played by Normandy in the emergence of the Impressionist movement through Anglo-French interaction.

Wynford Dewhurst can rest in peace.

Notes

1 Alfred Lys Baldry, *The Art of Mr Wynford Dewhurst*, an introduction in the catalogue of an exhibition of 'Paintings and Pastels by Wynford Dewhurst' at The Baillie Gallery, London, February, 1914.

2 Wynford Dewhurst, 'My Method of Work', *The Grand Magazine*, July, 1906, p. 998.

3 *Manchester Courier*, 3 February 1905.

4 Edgcumbe Staley, 'Impressionist Landscape Painting: Wynford Dewhurst', *The Crown, The Court and County Families Newspaper*, 15 June 1907, p. 494.

5 Wynford Dewhurst, 'The Secret of Success', *The Grand Magazine*, June 1906, p. 798.

6 *Manchester Courier*, 10 December 1908.

7 *Manchester Courier*, 26 March 1907.

8 *Kent and Sussex Courier*, 9 October 1914.

9 Reported in the *Leighton Buzzard Observer*, 3 July 1900.

10 *Leighton Buzzard Observer*, 12 July 1904.

11 *Daily Mail*, 20 April 1911.

12 *Manchester Courier*, 20 February 1914.

13 *Manchester Courier*, 24 February 1914.

14 Jennie Lee, the first Minister for the Arts, was appointed by Harold Wilson in his Labour government of 1964. She also played a key role in the founding of the Open University.

15 Christophe Rameix, *Impressionnisme et Postimpressionnisme dans la Vallée de la Creuse*, Joué-Lès-Tours, France, 2013, p. 57.

16 Letter in the archives of Manchester Art Gallery.

17 Recorded in a brief (unpublished) account of his father's life by Claude Dewhurst when he was canvassing in 1961 for an exhibition of Wynford Dewhurst's work.

18 *Daily Mail*, 2 February 1905.

19 See note 17.

20 *The Artist*, May, 1902.

21 *Leighton Buzzard Observer*, 16 October 1900.

22 *Manchester Courier*, reported in the *Leighton Buzzard Observer*, 16 April 1901.

23 In 1911 the French Government bought for the nation one of Dewhurst's pastels which is today in the collection of the Musée d'Orsay in Paris.

Epilogue

Wynford Dewhurst
c 1937

In many ways Dewhurst's whole career was a paradox. Born Thomas William Smith, he sought, and found, recognition and considerable success as Wynford Dewhurst. A family man, with traditional conservative values, whose political views were decidedly right of centre, he championed with passion a group of French artists whose work was described by one contemporary critic as 'the very anarchy of painting', and indeed, several of whom embraced anarchism as a means of achieving political ends.

A man described by one newspaper as 'a painter to his fingertips' and whose work found popular approval, but who is probably best remembered today for his writings, which sought to explain and justify a movement that was much misunderstood and maligned in his own country.

A proud British patriot, but an enthusiastic Francophile and admirer of everything French, he received honours from the French government and produced the larger part of his work in France.

Was Dewhurst a 'British' Impressionist, or a 'French' Impressionist? Certainly he was British by nationality, but he failed to develop a distinctly individual, or British, style. His devotion to his hero, and his proselytizing on behalf of the movement he so admired, meant that he did not establish his own interpretation of Impressionism. 'England's Claude Monet' he will remain, but he did leave us a beautiful body of work, which is worthy of rediscovery and reassessment. In 1910, when Dewhurst was at the height of his popularity and powers as a painter, the *Daily Express* wrote:

> Nothing could be more delightful on a cold, dreary day than Mr Wynford Dewhurst's landscapes imbued with sunlight ... Mr Dewhurst paints with rare distinction in the manner of the French impressionists. His oil paintings are spacious, fragrant with the scent of Normandy apple orchards, and seen with the mind as well as the eye.

An artist with such magical powers deserves to be remembered and appreciated.

Index

Page numbers in **bold** indicate illustrations

Acknowledgements

The ultimate responsibility for this book, and the accompanying exhibition at Manchester Art Gallery, must rest with my good friend Duncan Forbes, poet and painter, who introduced me to the work of Wynford Dewhurst and thus set me off on a journey of exploration into the life of this colourful character.

My special thanks must go to Professor Christiana Payne of Oxford Brookes University, who agreed to act as my unofficial mentor for the project. Her wisdom and extensive experience as a published author have been invaluable to me. I thank the staff at Manchester Art Gallery for responding to my suggestion that an exhibition of Dewhurst's work was long overdue, and embracing the idea with enthusiasm. Especially, I have enjoyed working with Hannah Williamson, Curator of Fine Art, who, as my co-curator for the exhibition, was endlessly optimistic and resourceful in the face of difficulties.

Wynford Dewhurst had six children and the family is widespread. All those that I have made contact with have been extremely cooperative and enthusiastic about the project, and have scoured their attics and family archives for Dewhurst papers and memorabilia. In particular I would like to thank Charles Dewhurst, Ted, Sarah and Sammie Coryton, Victoria Austin, and Nick Spurrier for their willing assistance and the faith they placed in me.

I am indebted to numerous museum and art gallery curators, archivists, librarians, owners of private collections and members of the art trade for help given towards the realisation of both the book and exhibition. They include Mr and Mrs R. Briggs, Pat Conibere, Laura Cotton, Mrs Azar Elliot, Nicholas Holloway, Natasha Howes, Jill Iredale, Richard Kay, Jean-Marie Laberthonniere, Cecile Lasnier, Peter Latto, Penny Marks of Richard Green Galleries, Sian Phillips of Bridgeman Images, Stephanie Roberts, Grant Scanlan, Peter Simons, Clare Smith, Stephen Whittle and Dan Brown of Bath for specialist photography. I would also like to thank Clara Hudson of Sansom & Co for her advice and patience and for ensuring that this publication is a worthy tribute to Wynford Dewhurst.

I am grateful to Manchester Art Gallery, the Marc Fitch Fund and the Art Fund for financial help towards the publication of this book.

My greatest debt is to my wife, Diana, for her unfailing support and encouragement.

Roger Brown